A–Z

OF

PRESTON

Keith Johnson

AMBERLEY

Acknowledgements

I must acknowledge the help given to me by the staff of the Harris Community Library in Preston, who willingly assisted as I delved into their archives. Their extensive records made my research that much easier.

My appreciation also goes to the newspaper reporters of the past who, in chronicling the events of their days, made this book possible. The *Preston Guardian*, *Preston Chronicle*, *Preston Pilot*, *Preston Herald* and, of course, the *Lancashire Post* all provided information from their publications. The Preston historians of old, in particular Anthony Hewitson, John H. Spencer, Peter Whittle, Charles Hardwick, Henry Fishwick and William Pollard, provided me with valuable sources of information.

Besides my own collection of images/illustrations, I would like to thank the *Lancashire Post* for permission to use images that are nowadays stored in the Preston Digital Archive. Also, my thanks go to Richard H. Parker, the creator of the PDA, for use of images from that source, and to Mike Hill, Communities Editor of the *Lancashire Post*, who was ever helpful in my research.

My thanks also to Pat Crook for checking my manuscript and putting her literary skills at my disposal once again in a cheerful manner.

First published 2018

Amberley Publishing
The Hill, Stroud, Gloucestershire, GL5 4EP
www.amberley-books.com

ISBN 978 1 4456 6644 0 (print)
ISBN 978 1 4456 6645 7 (ebook)

British Library Cataloguing in Publication Data. A catalogue record for this book is available from the British Library.

Origination by Amberley Publishing. Printed in Great Britain.

Contents

Introduction

This A–Z book is all about Preston's people, places and history. It is an opportunity to admire its progress from the days of poverty and pestilence to the thriving city of today. If you glimpse at the contents of this book, you will soon observe that it is not a definitive guide to 'Proud Preston', but is instead a journey from the deep past to the present day.

This book is not confined to the traditional constraints of an A–Z, merely listing everything and everybody from a place or time; it is instead an attempt to gather various historical elements, tales and anecdotes. In truth, it is a collection of features that I found fascinating to discover – I hope they will entertain you.

For each letter of the alphabet there were generally many options, so I hope you find the themes chosen as interesting and compelling as I did. Some of the people discussed are almost forgotten now, but their endeavours and adventures are well worth recalling. In many cases their achievements have been amazing, contributing much to history's rich tapestry. There are people who left town to seek fame and fortune and others who lingered or dwelt here awhile, leaving a large footprint on our streets. Adventurers, historians, illustrators, entrepreneurs, knights, lords, politicians, preachers, lawyers, lawmakers and lawbreakers have all left their mark and deserve closer inspection. There are features about famine and feasts, telegrams and telephones, umbrellas and the weather, steam trains and railway tracks, electioneering and rioting, and much more.

To plot this A–Z path through Preston's history, I have taken many twists and turns. This historical reflection takes us through many centuries and loiters awhile in the decades of the recent past. Hopefully, the book provides a few more of the missing pieces of the jigsaw of Preston, and will help make the picture a little clearer. It is apparent that the day-to-day achievements of our ancestors left a rich legacy and, after all, we should remember that what we create today will be history tomorrow.

A

Atticus – Anthony Hewitson's Legacy

Anthony Hewitson, the former editor of the *Preston Chronicle*, died at the age of seventy-seven on the last Saturday of October in 1912 at his residence in Prince's Crescent, Morecambe. It was farewell to the son of a stonemason who left a legacy of local historical knowledge that future historians would be ever grateful for. My introduction to local history began when I borrowed from my brother a copy of Hewitson's *History of Preston*, published in 1883 at the *Preston Chronicle* offices. In it I discovered a brief reference to the execution of Preston girl Jane Scott at Lancaster Castle, and it got my curiosity going to begin delving into Preston's archives myself.

Hewitson was born in Blackburn on 13 August 1836 and was raised in the village of Ingleton by his grandparents. His schoolboy days gave him many memories and he produced a series of articles in the *Lancaster Standard* in 1893 recalling them – times when bull-baiting, cockfighting, a travelling circus and a fair provided entertainment for the locals. He recalled with fondness the tasty cheese, the vicar in the pulpit, the church choir and the playing of football. And there was Mr Danson the schoolmaster who could teach you reading, writing and arithmetic and knew how to thrash a misbehaving boy!

Education completed, Hewitson joined his parents in Blackburn in 1850 before taking up an apprenticeship in the newspaper industry. Spells with the *Lancaster Gazette*, *Kendal Mercury* and *Staffordshire Advertiser* all contributed to his knowledge. Then in June 1858 the *Preston Guardian* beckoned, followed by the *Preston Chronicle*, the *Preston Herald* and the *Preston Guardian* again, where he became chief reporter. It was the perfect path for his next role as proprietor and editor back at the *Preston Chronicle*. Altogether he owned the newspaper for twenty-two years before it became incorporated with the *Preston Guardian*.

Much of his day-to-day work can be viewed in copies of the old newspapers, and we are fortunate that he left us with bound volumes of some of his treasures. Notable among them are a series of literary sketches of mid-Victorian members of Preston Town Council, and his epic work entitled *Churches & Chapels*, which gives an account of all the local churches, congregations and preachers back in 1869. He visited them all and drew a picture under the pen name of Atticus. It is an amazing account that pulls no punches and proves his powers of observation were second to none. There were the much-admired 'Then & Now' series of articles, which gave a fascinating insight into the development of the newspaper industry in

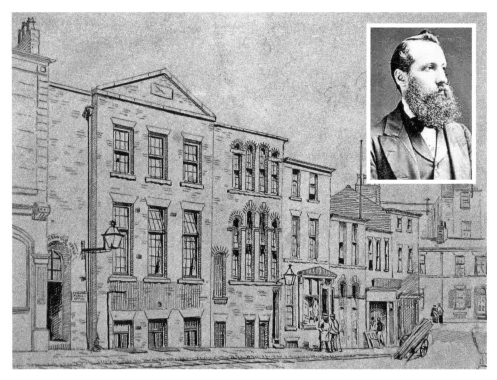

The *Preston Chronicle* offices and works on Cannon Street. *Inset*: Anthony Hewitson.

Preston and the early newspapers and journals that chronicled events. And, of course, there is also his painstaking work in compiling the Preston court leet records – as only he could do.

Hewitson was also a man who liked to broaden his horizons, and ventured abroad, sharing his experiences with his readers. Such a time was in April 1884: after he visited America he delighted *Preston Chronicle* readers with an account of his adventures. Under the title 'Westward Ho', he told of his train journey from Chicago to Cleveland and how, on the railway station, he had encountered John Huntington the Preston cotton outcast, who was by then an oil millionaire and who invited him to dine at his spacious residence.

Once the shackles of producing a twice-weekly newspaper were removed from him, he produced a book that is truly amazing called *Northward*. It was published in 1900 and describes the road from Preston to Lancaster, which he travelled along on foot and horseback, stopping off at the villages and hamlets either side of the thoroughfare – now the A6. Packed with illustrations and many anecdotes, it was testimony to his humour and his ability to make history interesting.

Most of his retirement years had been spent at his home in Queen's Road, Fulwood, but declining health necessitated his moving to Bare to take the fresh sea air blowing in from Morecambe Bay. Needless to say his passing was mourned, and his funeral took place at Preston Cemetery the Wednesday after his death. Although he passed on over 100 years ago, his works are timeless and they remain at the forefront of Preston's history. Thank you Mr Hewitson, without you I would have not written a single tale.

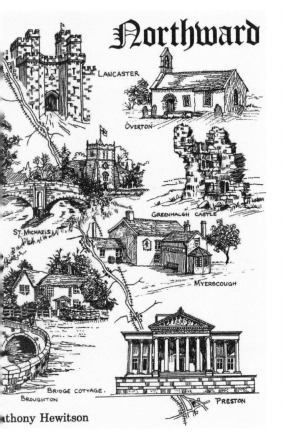

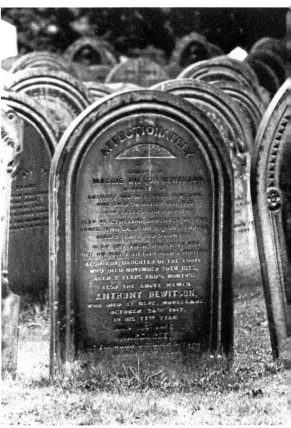

Left: *Northward*, a popular book published again in 1993.

Right: Hewitson's grave in Preston Cemetery.

Baseball – When PNE Turned to Baseball

Baseball boys and Preston North End have what may seem nowadays an unlikely link. Preston North End have their name in the Soccer Hall of Fame for winning the first Football League Championship, but they can also lay claim to another first: their sporting achievements back in the Victorian summer of 1890.

By the third Saturday of March 1890, Preston North End had clinched their second successive Football League Championship. It was a relief for Chairman William Sudell, who had seen his charges lose their grip on the FA Cup when the Bolton Wanderers inflicted defeat on them in the quarter-finals.

Besides their twenty-two League fixtures, the North End team had played regular Challenge matches and by April had competed in over fifty fixtures. Consequently, the North End team had hopes of putting their feet up for the summer, but Major Sudell had other ideas. No sooner had they celebrated their trophy triumph, than the players were informed of the club's intention to compete in the inaugural National Baseball League involving Football League clubs to fill the void in the summer sports calendar.

Early enthusiasm was found wanting, and only four clubs agreed to take part in the Baseball League: North End (playing at Deepdale), Stoke, Aston Villa and Derby County. To add to the attraction of the competition, leading American baseball players were brought over to play for the teams, the only stipulation being that they were not allowed to pitch. North End obtained the services of Samuel Leech Maskrey, who played for Louisville Colonels in the American Major League.

Maskrey taught the players what he could in the short space of time available before their mid-June encounter with Derby County at their aptly named Baseball Ground. The Preston team performed well before the several thousand spectators, but in the end lost by 6 runs to 4. Two days later, Aston Villa visited Derby and they were beaten by 4 runs to 1, leaving Derby County as the firm favourites for the title.

North End's participation in the baseball arena gained quite a bit of local interest, and the first ever match at Deepdale took place on the third Saturday of June in 1890. The visitors were Derby County. The North End side led by Maskrey was a mixture, with seasoned professional

footballers such as goalkeeper James Trainer, Billy Stewart and William Hendry being joined by a number of youthful enthusiasts. Watched by around 500 spectators, the Preston team had to admit defeat against their more experienced visitors. After four innings each, the visitors had scored 8 runs without reply. Despite North End rallying in the closing stages, Derby clinched the game 9-6.

On the following Monday evening, Aston Villa provided the opposition and an unchanged Preston team was involved in a high-scoring match. Watched by some 300 spectators, the players gave everything in their nine innings and Aston Villa eventually ran out the winners by 10 runs to 8. Despite the losses the signs were good for Preston, who had shown great improvement with each fixture, which was evident as they dropped their losers tag and embarked on a winning sequence of four successive games by late July.

Next up were Derby County at the Baseball Ground, and this time a Wednesday evening fixture saw North End gained the favourites. After the sides had completed their nine innings the score was deadlocked at 10 runs each and in the deciding innings North End gained the crucial run. A day later the North End were away to Aston Villa; once again the North End team showed their superiority and, led by the enthusiastic Maskrey, they triumphed by 18 runs to 9.

At this time there was a certain amount of acrimony with the Derby team being accused of unfair practices by fielding a number of experienced American baseball players. Despite being

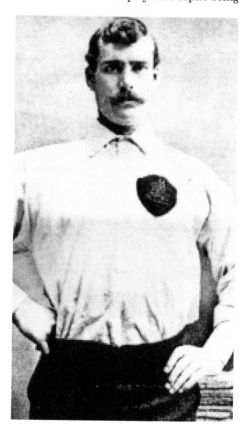

James Trainer – goalkeeper to baseball star.

clear leaders of the Baseball League they chose to resign from the competition, leaving the resurgent Preston with an unexpected opportunity to clinch the title.

Going into August, the departure of Derby County meant that the Championship table was led by Aston Villa with 24 points – a lead of 4 points over North End – with Stoke well adrift, having just three wins from seventeen fixtures. In the weeks that followed, the Preston team continued with their improved form in the championship fixtures.

The final Championship fixtures were set for the third and fourth weeks of August, with Deepdale being the venue for the two encounters against Stoke. On the Monday evening, attracted by a double header, over a thousand spectators flocked to the ground. The first game began at 5 p.m. and, in a match of five innings each, the home side won by 13 runs to 2. An hour later the second game got underway, and once again Preston had the upper hand. This time they rattled up a score of 17 runs to 1 inside three innings before a downpour of rain halted proceedings.

During the final week, Preston had to visit Perry Barr to face Aston Villa in the final fixture of the Championship. The North End team of Hendry, Livesey, Sanders, Colford, Gillespie, Trainer, Stewart, Hogan and skipper Maskrey had been virtually unchanged throughout the summer and their visit to Birmingham saw the side victorious once more, gaining a 26 runs to 8 score. The result meant that Preston North End had finished as Championship leaders with 36 points from their twenty-eight fixtures, with Aston Villa being just 2 points behind.

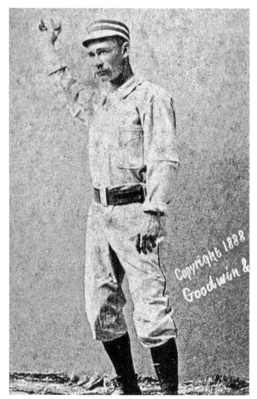

Samuel Leech Maskrey came from the USA.

At the Baseball League meeting on the following Wednesday, the North End were confirmed as holders of the Championship pennant by the Board of Management.

The following evening the North End team gathered at the Shelley Arms Hotel in Preston to officially thank Leech Maskrey for his great efforts in leading them to the pinnacle of the new national sporting competition. With the American about to embark on his journey home he was presented with an inscribed pendant by Major Sudell, who thanked him for his achievement with North End and told him he looked forward to the day aside from Deepdale would be able to challenge the might of American baseball.

Alas, it was only a dream, because the following summer the League failed to get off the ground and when the domestic competition again took place in 1892 it was based in the North East. As for Derby County, they regrouped, and from 1895–98 they claimed the title three times, with the Baseball Ground being very much at the forefront of the national sport. North End hero Leech Maskrey had further success with the Louisville Colonels and Cincinnati Red Stockings before retiring from the sport. He died in Pennsylvania in Guild Year 1922, aged sixty-eight, and was remembered back in Preston as the man who made the rookies of North End into baseball champions.

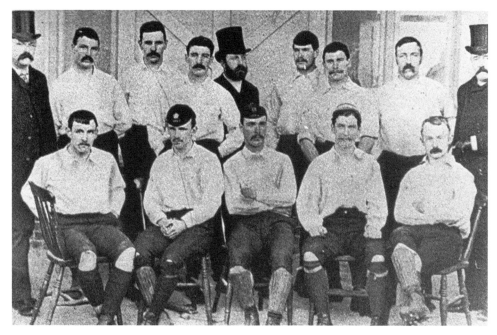

Preston North End – football champions to baseball stars.

Curling Club of Preston

Curling clubs are common in Scotland, and in Preston one group of hardy souls always seemed delighted when the long, dark, cold and freezing winters arrived – the members of the Preston Curling Club. Curling is a sport wherein players slide stones along sheets of ice and has come to public prominence at the Olympics in recent times. It is said to have its origins in medieval Scotland in the sixteenth century and is governed nowadays by the World Curling Federation.

The enthusiasts of the game in Preston – no doubt inspired by the Caledonian Curling Club – held a meeting in the Red Lion on Church Street in Preston in mid-September 1871 to establish the sport locally. Those hardy souls had, by January 1875, managed to get a rink at Farringdon Park and arranged a fixture against the Rose & Thistle Club from Blackburn. Two years earlier the Preston team had been vanquished at Blackburn, but this time they were triumphant. The day was cold and the ice keen yet dry, and Preston skips Messrs D. Jardine and William McKie led their quartets to victory. Once the match was over both teams were conveyed to the Mitre Inn in Preston for a cordial reception.

The thriving Preston Curling Club, 1909.

During the cold spell of December 1878 the Preston Curling Club enjoyed local contests at both Farringdon, where the Preston Pleasure Gardens had been formally opened in 1877, and a rink at Ashton. They also competed at home and away for the Caledonian medal, with visits to the likes of Ulverston.

Many a frosty day followed in the decade ahead, and the local enthusiasts increased in numbers. By late December 1887 they were able to announce that, after reaching agreement with the management of Preston North End Football Club, they were to rent a patch of low-lying land, suitably flooded, as their new Deepdale rink for £30 per annum. A team from Southport provided the opposition on an ideal freezing afternoon. This Southport side had their own 'Glaciarium', which opened in 1879 and proved to be formidable opposition in a drawn fixture. Few severe winters pleased our Victorian curlers more than that of 1895: weeks of frozen rivers, lakes and ponds saw participation flourish, particularly at the Deepdale rink.

Internal competitions and organised club fixtures increased each year and by the dawn of the twentieth century the Preston Curling Club had a competitive team. Upwards of thirty curling clubs had been established in England. This led to intense competition and visits to Scotland, where conditions were more favourable for longer in the season.

One of the highlights of each season for the Preston club was their annual dinner, which always had a Scottish flavour to the menu. At their dinner in late January 1902 they looked forward to the forthcoming fixtures in Scotland, to which they would send four rinks (sixteen players) to compete with the finest teams. With a playing membership of upwards of ninety, the club was popular and respected. By 1909 the club had moved to a rink at Ribbleton, and by the 1920s they took over the Fulwood Old Reservoir as their curling pond.

Ever keen to practice and perfect their winter sport, they often took to the road and played at the Manchester Ice Palace, which opened in 1910. Their dedication was rewarded in April 1920 when they won the coveted Newall Cup, guided by skip William Kerr, by beating Belle Vue 8-7 at the Manchester Ice Rink.

The winter of 1933 was one that became a curler's dream when an extended cold spell meant a number of practice sessions could be played on the Fulwood Old Reservoir for the first time in

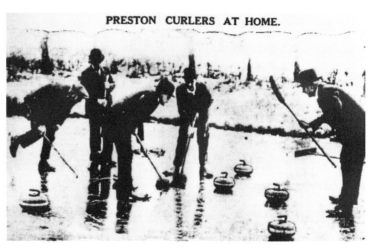

PRESTON CURLERS AT HOME.

The Preston curlers getting welcome practice in 1933.

years. The rink was in perfect condition for practice, although their fixtures would still be played away from home. That frosty spell seemed to serve them well, because by December 1934 they were travelling to the Edinburgh Ice Palace to compete in the World Curling Championship with a quartet skipped by William Kerr. Kerr, a regular England international, had twice led Preston to the final of the I'Anson Cup – the Blue Riband of English curling. Competing with 100 teams they won through to the last sixteen, where Galashiels beat them after an extra end following a tied match.

In the years prior to the Second World War the Preston Curling Club's annual dinner was one of the social highlights of the year, attended not only by the curlers but a number of local dignitaries too. The *Lancashire Evening Post*'s cartoonist, Furnival, was often among those present and captured the enjoyment of the occasion with larger-than-life sketches of the proceedings.

With its roots in Victorian days, curling was originally an exclusively male-dominated sport, but these days the thrill of competing on ice is enjoyed by members of both sexes with male, female and mixed events the order of the day.

Those early pioneers of the sport of curling in Preston laid solid foundations and today the Preston Curling Club is a member of the English Curling Association. Their secretary is Phil Barton, who has represented England at World Championship level and has been involved in arranging fixtures for the team, who play matches at Lockerbie and other far-flung venues, and the prestigious I'Anson Cup is still competed for. With plans for a curling rink within the new multipurpose leisure complex at Barton Grange, the sport might well flourish once more in Preston.

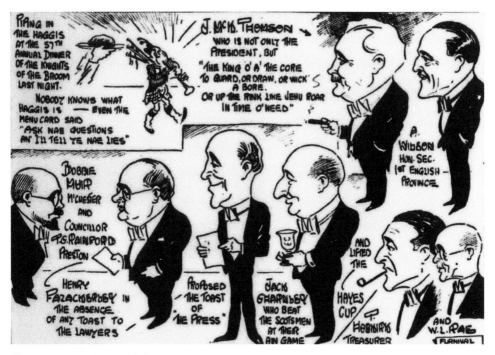

Illustrator Furnival attended the annual dinner in 1933.

D

Dancing – Grand Balls and Disco Dancing

Dancing days and nights have been part of Preston's social scene since the earliest of times, with generation after generation looking back with fondness on the nightlife and dancing scene. If we delve into the archives there are many mentions of grand balls and masquerades, certainly with regards to the Guild celebrations held every twenty years. Indeed, as long ago as 1602, Dr Kuerden informed us that after the great Guild Banquet in the Guild Hall, the ladies were treated most nobly with pleasant music and they displayed their skill in dancing at the ball.

The Assembly Rooms of the Bull Inn were a popular place for those of high society to mingle. In February 1831 the privileged classes held a ball there, and with the price of a ticket at 7s (including refreshments) it was certainly exclusive. In the same week the parishioners of St Wilfrid's packed into a schoolroom of the Catholic school on Fox Street to dance the night away at their annual ball, raising £20 for school funds. In the 1830s the Corn Exchange Rooms on Lune Street hosted a 'Preston Bachelors' Ball' on 14 February each year, with strict rules regarding the arrival of carriages and a ruling that partners must change after each dance.

A Grand Costume Ball, held in January 1845 at the old Town Hall in the Market Place, drew much interest, with a great crowd waiting outside to observe the dignitaries entering dressed in all their costumed splendour. The Town Hall ballroom was in much demand in those days, with such events as the annual ball held to raise funds for the female orphan house.

In the mid-nineteenth century there was quite a lot of improvisation going on as folk took to the dance floor. In October 1852 on the feast of St Crispin, over seventy people sat down to a supper at the Blue Bell Inn on Church Street; afterwards, the tables were cleared away and they danced until the early hours. A similar event took place at the Grecian Inn on Lord Street. Back in those Victorian days the George Inn Concert Hall at the top of Friargate, the Sun in Main Sprit Weind and the Guild Tavern behind the parish church among others regularly had a bit of dancing mingled with the bawdy activities that often took place as the gin flowed.

In 1862 the Guild survived the Cotton Famine that gripped Lancashire and a grand costume ball was held in the Corn Exchange. Such organisations as the Preston Volunteers, the Preston Royal Infirmary, the local Conservative Club and Maudland Society would go on to hold their annual gatherings there. By the next Guild in 1882 the Corn Exchange had been renovated and was known as the Public Hall, which played host to the Guild Balls. The place would go on to

CATHOLIC BALL.

THE ANNUAL BALL for Benefit of the FEMALE ORPHAN-HOUSE, and other Catholic Charities of Liverpool, will be held, by permission of the Mayor and Town Council, at the TOWN-HALL, on MONDAY, 11th February next.

LADY CAROLINE TOWNELEY, Lady Patroness.

Tickets, 10s. each, (Refreshments included,) to be had at Messrs. ROCKLIFF and SON's, Castle-street; Messrs. HIME & SON, Church-street; Mr. PARSON's, Bold-street; and at the usual places.

The doors will be opened at Half-past Eight.

The Catholic Ball at the Town Hall, 1850.

become a focal point for dancing of all types down the next century, playing host to the leading bandsmen and those groups and artistes who brought their top of the pops music to town. It was still a popular venue in the 1960s, and although its days were numbered it still had the capacity to attract great entertainers such as the Beatles and the Rolling Stones. The Saturday night dances at the beginning of that decade regularly drew a crowd of 1,000 or more.

One ballroom remembered with fondness by the older generation is the Hobkirk Dance Centre, formerly the Adriatic Ballroom on Lancaster Road, which had its roots firmly planted in the late Victorian days. The Adriatic was the brainchild of Frank Foster who, aware that the famous liner was being broken up at Ward's shipbreaker's on Preston Dock, salvaged panelling, decking and wall mirrors to create a first-floor ballroom above his family's foundry. Generations of dancers flocked there and many in later years were taught their first steps under the guidance of Wally Hobkirk.

The Regent Ballroom on Tithebarn Street was, from 1926, a place to be seen for many of Preston's younger people, who danced the night away on the finest of dance floors. For over twenty years, in the era of the clarinet, trumpet and accordion, the resident band was the J. S. Higson Band; music for a quickstep, foxtrot, waltz and tango all echoed around the ballroom. There was also the Majestic Ballroom in Tenterfield Street owned by market trader Matt Wade, with the popular Tommy Chadwick as band leader. The Queen's Hall was a venue that re-emerged every winter from the mid-1930s, when the large pool of Saul Street Baths was turned into a concert and ballroom arena. The place entertained in the era of big bands and swing with orchestras aplenty. Band leaders such as Lee Marsden, Bill Shuttleworth, Stan Rothwell and Cyril Stapleton were familiar to the Queen's Hall crowd.

If you felt that you had two left feet but got the urge for dancing, then Preston's couple of dancing champions, Carol and Nick Atack, might possibly have guided your first steps on the

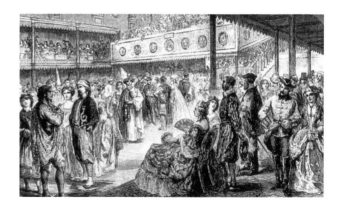

The Costume Ball at the Corn Exchange, 1862.

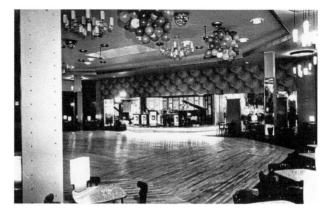

The Top Rank Ballroom, 1963.

dance floor. They took over a neglected old printing works in Avenham Street and transformed it into a luxurious dance studio in 1978. Dancers, originally formed in 1968, was a significant venue for all age groups as it taught old and young alike all manner of dances.

On Church Street the Top Rank Ballroom opened in 1963, where a mixture of ballroom and disco dancing took place every night of the week as partygoers danced the night away to pop, soul and Motown sounds. There was a strict dress code for the fellows: a suit and tie – no suede shoes – was the order of the day. The music of the Hollies, Freddie & the Dreamers, the Searchers and the Rolling Stones gave the place a flavour of the 1960s pop scene. In 1974 the venue was transformed into a heavenly nightclub called Clouds – the perfect venue for the over twenties, who flocked there week after week. Clouds was certainly the place to strut your stuff for a number of years, but eventually, in an ever-changing world of music, it closed. The club relaunched in September 1989 as Easy Street. The younger generation now recall the venue's later days as Tokyo Jo's, and in October 2006 the venue was launched once more as Lava & Ignite.

During the 1960s many a modern parish hall or youth club emerged in the town and such venues as Canterbury Hall, St Oswald's, St Joseph's, St Augustine's, St Gregory's, St Anthony's, St Walburge's and St Ignatius held dances on a regular basis, attracting both young and old alike. One place that seems to live long in some memories was the Catacombs, an apparently smoky, poky little club on Derby Street – rhythm and blues and music from Merseyside were sure to get you grooving there.

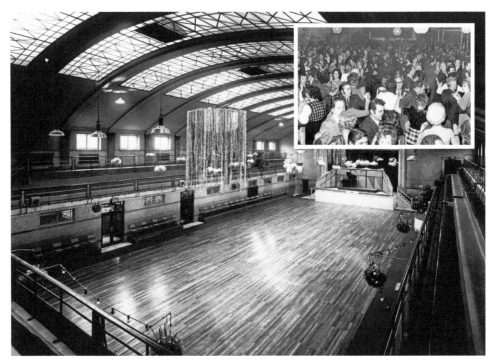

The Queen's Hall changed from a swimming pool to a dance floor each winter. *Inset*: The farewell dance at the Public Hall, May 1973.

Plenty of dancing down the decades has taken place at the Guild Hall, which officially opened in 1973. Whether it be a candlelight dinner dance hosted in the Celebrity Restaurant, non-stop dancing to the Syd Lawrence Orchestra or simply a Thursday night disco, many were left with memories to cherish.

The world of night-time entertainment, introducing alternatives to dancing all night long, began to appear in the 1960s and by the summer of 1967 Preston folk were being attracted to the Flamingo Casino Club in Great Shaw Street, where besides a dance you could spend time playing brag, blackjack or roulette, if you fancied a flutter. It was later known as Samantha's Nightclub and then became the Cherry Tree. The Club Royale on Market Street was another venue attracting those seeking nightlife. Down the decades this venue has had many a name over the door, including the Worsley's Dance Hall, the Gatsby Night Club, Molloy's Dance Club, the Millionaire's Club, Club Solid and finally the Blitz, prior to its recent demolition.

In 1979 a sumptuous cellar nightspot named Squires was unveiled underneath the Lancastria Co-op building after a £500,000 investment. Chandeliers and Greek statues in the foyer and a solid marble staircase gave you an idea of the grandeur inside. The Squires' dancefloor and the Snoopy's disco are remembered fondly by those who visited in the early days. The later branding of Cameo and Vinyl ended in October 2016 and it reopened as Switch in August 2017.

Many people have fond memories of the Scamps discotheque, which opened on the former Ritz Cinema site on Church Street. Its popularity waned in the early 1980s and the venue was relaunched as Brooks in February 1983 after a £250,000 revamp. Alas, that venture was short-lived.

Since 1972 the Warehouse (for a time known as Raiders) has been an alternative nightclub and music venue in Preston. Its popularity in the late 1970s earned it a reputation as a leading punk rock venue. Many on the road to fame have appeared here, including the Stone Roses and Joy Division. The Piper on Tithebarn Street was certainly a popular venue for many years too. It went on to become Barristers, before assuming the title Lord Byrons. Many will recall a visit to the Piper in their younger days from the mid-1960s onwards. In 2001 it opened as Storm, a venue for over twenty-fives, and later became Club Arena.

Not surprisingly the emergence of UCLAN led to many club nights, gigs and dance parties in the 1990s within the 42nd Street Bar and the Venue, eventually leading to the building of 53 Degrees on Fylde Road, a venture that was recently doomed to failure. The Mill on Aqueduct Street was another live music centre designed to attract students, which opened in October 1998 with Freak of Nature topping the bill.

These days you can visit the new Blitz on Church Row – the Blue Moon Inn of the 1990s; Roper Hall is an established venue for DJs and musical diversity; the old Macs nightspot on Friargate is open for dancing once more as Placebo; Switch is the name over the old Squire's nightspot; Studio Evoque (formerly Clouds) is on Church Street; the old Ritz site is now simply the Mokai Night Club; the Warehouse remains in St John's Place; and the Piper's doors are locked as it awaits conversion to shops. The Guild Hall is under new management; here you can delight in a Tea Dance, get in the mood with the Glen Miller sound or attend a Carnival dance.

So, generations of Preston folk can wallow in the nostalgia of their dancing days and those of a younger age have plenty of choice to dance the night away – although, in most cases, the dancing won't be of the *Strictly Come Dancing* fashion.

Venues of the twenty-first-century dancing scene.

Elections – An Election that Stirred the Passion

Elections of our parliamentary candidates always stir much interest and passion. If we cast a glance back 250 years, we will see that it was even more passionate in eighteenth-century Preston, when election time meant rioting and bloodshed as the battle for the parliamentary seats took place.

At the election of 1768, when Preston's population was around 5,000, four contestants sought two seats in the House of Commons: Sir Henry Hoghton and John Burgoyne stood for the Whig interest with the backing of the Derby faction, and Sir Frank Standish and Sir Peter Leicester represented the Tory party and the interests of the Corporation of the Borough.

John Burgoyne, who was born in Sutton, Bedfordshire, in 1722, was no stranger to Preston as he had been stationed in the town during the 1740s when he had been a lieutenant in the 13th Light Dragoons. While based in Preston he had frequently visited Knowsley to share the company of his old school friend James Smith-Stanley, commonly known as Lord Strange, the eldest son of the 11th Earl of Derby.

During his visits he became acquainted with Lady Charlotte Stanley – his friend's sister. Their meetings developed into a loving friendship and this led to an elopement with her in 1751. The relationship had the approval of her brother but was frowned upon by Lord Derby, whose reaction was to sever the couple's ties with the Stanley family. A number of years in London and then France followed for Burgoyne and Lady Charlotte before they eventually became reconciled with Lord Derby.

By the time of the election of 1768 the by then General Burgoyne had the full backing of the Stanley household. He entered the contest with an impressive military background and with the experience as an MP, having previously been elected to represent Midhurst in 1761.

The election contest that followed was to eventually be referred to in local annals as the 'Great Election'. For a period of eighteen months its influence was to be felt on the life of the town. There were scenes of bloodshed and many brutal skirmishes between the contending parties, and it is on record that Burgoyne rode through the town with a pistol in each hand. One of the battle cries was 'leave not a freeman alive'. Lawless bands of colliers from the neighbourhood

of Chorley were in Preston in the interest of the Corporation candidates, and from Longridge and Ribchester came armed blackguards in the support of the opposition.

For upwards of six months before the voting, the town was at the mercy of the hired bludgeon men. The inflamed mob even went to the length of destroying places of worship and the Roman Catholic Church of St Mary's on Friargate was sacked.

On one occasion in Fishergate Mayor Robert Moss was seized and soused under a pump. Dishonourable methods were employed and disturbances and destruction were the aim. Most of the windows in the town were broken and many buildings were barricaded against the mobs.

The London papers as well as the Lancashire press condemned the methods employed to procure votes. The mayor and Corporation maintained that only freemen or in-burgesses were entitled to vote, while the Whigs and the Derbyites strictly supported the claim that all the adult male population were eligible to cast a vote.

The result of the election held from 21 March until 2 April was that the nominees of the Corporation were returned, namely Sir Frank Standish and Sir Peter Leicester, despite receiving fewer votes. According to the mayor a 'freemen only vote' was the official outcome, with Leicester receiving 289 votes, Standish 276, Burgoyne 259 and Hoghton 230 – Leicester and Standish being duly elected. The defeated candidates promptly petitioned Parliament against the elected members and the House of Commons ruled that other votes cast by the inhabitants at large must be included, leaving the state of the poll thus: Hoghton 558 votes, Burgoyne 589, Leicester 290 and Standish 277. Therefore Leicester and Standish were unseated and Hoghton and Burgoyne elected in their place. The Whig Party, under the leadership of the Duke of Grafton, were happy to have two more members among their ruling party. As a result of this Preston enjoyed universal adult suffrage prior to the Reform Act of 1832. The Corporation keenly felt this rebuff to their ancient rights and privileges, and their power was never the same afterwards.

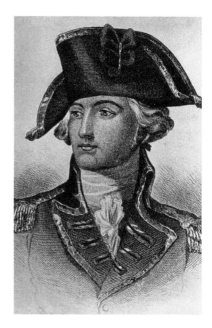

John Burgoyne, who was popular in Preston.

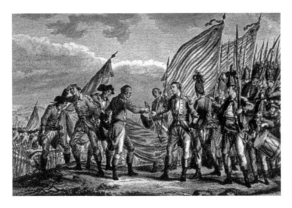

Surrender on the battlefield for
General Burgoyne.

The rioting was the subject of a trial in May 1769 and as a result Burgoyne was convicted of improper practices and ordered to pay a fine of £1,000; a number of rioters were imprisoned for six months.

While serving as Preston's MP, General Burgoyne became involved in the American War. It was the campaign of 1777 for which he is best remembered. He went to Canada in command of the British Expeditionary Force. After a couple of small battles, in which he was successful, he crossed the Hudson River to engage the Americans on their own soil. His army was engaged in a ferocious battle, during which he lost many men. The losses and sickness among his soldiers forced him to camp at Saratoga in order to rally his troops for the final battle. Gradually, the enemy closed in on all sides and Burgoyne's army was surrounded. His orders had been to meet up with Lord Howe and his army at Albany, although Lord Howe, oblivious to the intentions of General Burgoyne, was marching his troops towards Philadelphia.

Reduced by desertions, sickness and lack of supplies, General Burgoyne was forced to surrender to General Gates of the American army. He and his army were well treated by the colonists as they were marched to various encampments – the popular officer later paid tribute to their kindness and generosity in Parliament.

Burgoyne was allowed to return to England on parole, but later the Americans demanded his removal from the House of Commons. However, through the intervention of Benjamin Franklin, one of the founding fathers of the USA, whom Burgoyne is believed to have met in Preston, the claim was eventually waived.

He played an active part in Parliament and often spoke on questions affecting the army, the improvement of the soldier's lot and India. Certainly his popularity in Preston increased and, in all, he and Sir Henry Hoghton were returned to Parliament by the inhabitants of the town in 1774, 1780, 1784 and 1790.

In his later years he devoted much of his time to the theatre and was in fact the author of several plays. A flamboyant character with great wit he was in demand in the very best of society. He died in August 1792 and was buried in the cloisters of Westminster Abbey near to his beloved wife Lady Charlotte. Sir Henry Hoghton also died within that Parliament in the year 1795.

The election of 1768 had repercussions on the eligibility of voters in Preston, taking a step along a path that led to the votes for all policy enjoyed by Preston folk today.

F

Fazackerley – A Law unto Themselves

Henry Fazackerley is a name you will undoubtedly come across if you delve into Preston's twentieth-century court archives. He came to prominence in Preston in 1906 when he was part of the defence team in the trial of Patrick Callaghan and Thomas Beardwood, accused of murdering the dry-salter James Fell in his warehouse behind Preston Parish Church. On that occasion Callaghan was sentenced to death, but eventually reprieved and served nineteen years in prison; while Beardwood was ordered for retrial and received an eventual not guilty verdict. Fazackerley remained convinced that neither man was the perpetrator of the awful crime.

In 1928 Fazackerley was involved in the trial of Walter Brooks, who was accused of murdering his wife Beatrice Brooks and her lodger Alfred Moore in Avenham Road. On this occasion Brooks was sentenced to death and, despite pleas and petitions prompted by Fazackerley, he was executed on a June morning.

In 1939 a shocking tragedy at Fulwood Barracks led to his involvement in the defence of killer Sergeant Smith of the Loyal Regiment after the death of his wife and daughter. Found guilty of murder he was set to hang at Walton Gaol, but Henry Fazackerley lodged a successful appeal to save his life. The Home Secretary, Sir John Anderson, commuted the sentence to one of detention during His Majesty's pleasure.

In July 1962 he represented Joseph McCrorey, who was convicted of the murder of Mary Elsie Salter at the Kendal Castle public house in Lathom Street. He was found guilty of murder and set for execution, but Fazackerley lodged an appeal and it was changed to manslaughter and life in prison instead.

Being a senior partner in the solicitors firm of Smith, Fazackerley & Ashton of Cannon Street he was involved in an endless stream of high-profile cases. Down the decades he earned a tremendous reputation as a lawyer for the defence, with many a criminal grateful for his intervention. Not surprisingly, his advice and advocacy was sought throughout the North West and he prepared many major cases for the Director of Public Prosecutions.

Inevitably, he became a well-known character in the town and was seen as an elegant, witty, ostentatious and proud individual who displayed his eloquence in the local courts. He was a familiar figure often seen walking through the town centre smoking a huge cigar of Churchillian size, dressed in suits made in Paris, a homburg hat, spats, gloves and carrying his treasured silver-knobbed walking stick.

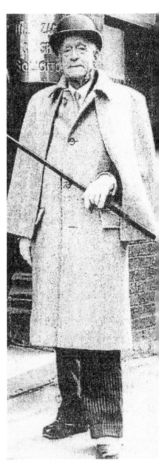

The Cannon Street offices, where Henry Fackerley (right) had many legal tussles.

One of the pioneering motorists of far-gone days, he had a passion for large yellow cars and would park up outside his Cannon Street offices before there were double yellow lines and traffic wardens. Living as he did at Kingsway House in Penwortham, he and his wife often entertained. They provided charming hospitality for their visitors in a gracious manner with tea or coffee, sandwiches, cakes and excellent conversation.

He had a passionate interest in politics, holding official positions within the Preston Conservative Association. For a time he was a steward within the Lune Street Wesleyan circuit and, during the Second World War, he ended up as commandant of the Preston Borough Special Constabulary. He spent many happy hours with friends at Preston's Victoria Bowling Club and was president of the Preston Municipal Bowling League. His distinguished record of public service earned him a CBE in 1956.

Despite his busy schedule, he and his wife would spend several winter weeks in Monte Carlo strolling along the Riveria Esplanade, sending postcards to friends in Preston, bringing a ray of sunshine back home.

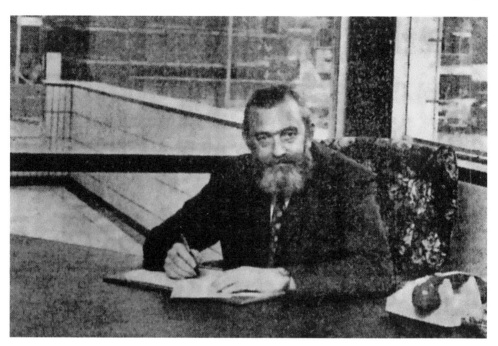

Derek Fazackerley, county coroner from 1967–72.

Active throughout his life, he died suddenly in December 1970 – just two months away from his ninetieth birthday. His death occurred less than three months after that of his wife of over fifty years. Among the many mourners at his funeral at St Mary's Church, Penwortham, was his only son – Derek Fazackerley, the county coroner.

Like his father, Derek Fazackerley became a partner in the Preston firm of Smith, Fazackerley & Co. He became a deputy coroner in 1961, progressing to county coroner in 1967. He gained the reputation of being a controversial coroner who was often critical of councils and government. It was something of a surprise in June 1972 when he decided to quit his county coroner role and retire at the age of fifty-two. Tall in stature, he was a forceful, vigorous personality who always considered the grief-stricken families and their needs. He dispensed with the old custom of having all the post-mortem evidence read out by the pathologist to spare unnecessary distress. Inquests were often of a wide variety and during his last year of office he had ruled over a murder verdict, two manslaughter's and eight deaths caused by dangerous driving. With over 3,000 inquests behind him, he was off with his wife to a cottage in a small village in Herefordshire and the delights of rural life.

Sadly, the days of growing his own food, raising sheep and fishing a stretch of river he owned were all too short. Preston folk were shocked to hear the news in February 1979 that Derek Fazackerley had died less than seven years after realising his dream.

Certainly, the Fazackerley's left an indelible mark on the history of Preston and its justice system, playing their part in a proud town's growth. Be it law courts or coroner's court, there always seemed to be a Fazackerley about helping to dispense twentieth-century justice.

Guilds – A Cycling Legacy from the Preston Guild

Guilds held in Preston every twenty years often leave a legacy behind and, with the introduction of the Guild Wheel, the Preston Guild of 2012 was no exception. Cycling enthusiasts are plentiful in Preston, following the introduction of the 21-mile-long orbital route in 2012, which created a great interest in the sport of cycling in Preston. Daily, enthusiasts both young and old take to the Preston Guild Wheel on a circuit that goes through Preston's green and pleasant lands.

In truth, cycling in Preston has been popular from the days of the boneshaker and penny farthing. In 1861, the first boneshaker bicycle hit the roads, and it was fine-tuned over the next two decades, leading to the invention of the ordinary bicycle, which earned its penny farthing nickname due to its large front wheel and smaller rear wheel.

In 1877, Preston Cycling Club was formed with its headquarters at the Shelley Arms Hotel on Fishergate. The club's first race was held in 1879 at the Preston Pleasure Gardens and the gold medal was won by Laurie Clarke who started from scratch in the handicap. The club also played their part in the Preston Guild of 1882, helping to organise a procession of cyclists numbering over 350 who met at West Cliff in late afternoon and paraded through the streets, causing great excitement along the way.

Notable among Preston Cycling Club's members was Sanders Sellers, who was at the forefront of early bicycle racing. By the summer of 1885 he could claim the record for 1 mile in a time of 2 minutes and 39 seconds. His success naturally made the sport popular in the town and his racing performances were followed keenly by the people of Preston. On the second Saturday of June, he journeyed to Birmingham to take part in the One-Mile Bicycle Championship of Great Britain, organised by the National Cyclists Union. In the final, Sellers was locked in a battle with Chambers and Illston, two formidable cyclists from Birchfield. However, he managed to find the final surge necessary to cross the line half a length to the good, in a time of 2 minutes and 46 seconds.

The Preston Cycling Club, of 1877 origins, would soon be enjoying twice-weekly cycle rides and it was certainly boosted by having Sanders Sellers, Laurie Clarke and other outstanding cyclists among its members. From the beginning, the club decided to wear distinctive gear of a peaked cap and knickerbockers. They also purchased a bugle that was used to warn riders of

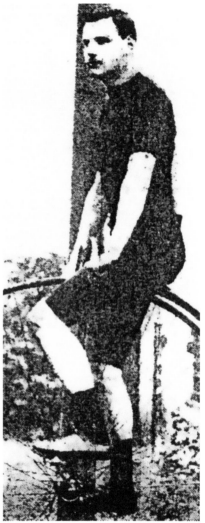

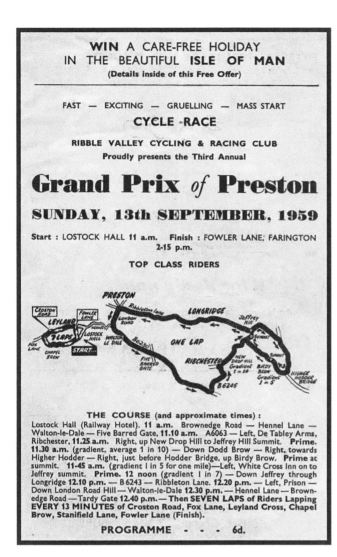

Left: Cycling Grand Prix of 1959.

Right: Sanders Sellers – Preston's UK champion.

stopping places and any hazards on the route ahead. In 1890 the club would move in another direction with the renting of a rambling country house known as Broad Fall in Scorton. In truth, the organised cycle runs would become less frequent, with members happy to ride out to Scorton for the weekend and relax at their country retreat. They enjoyed a number of pastimes while there such as cricket, tennis, swimming and – perhaps most significantly – golf. Sadly, these idyllic days ended in August 1911 when the tinder dry-thatched roof of Broad Fall caught fire and the building was destroyed.

A short spell at Inglewhite Lodge followed, and then in 1917 they purchased Fell Barn and some 30 acres of land high up on Longridge Fell for the princely sum of £550. Instrumental

in the move was the popular former mayor of Preston William Edward Ord, who became president of the newly named Preston Cycling Club & Longridge Golf Club. In reality, it was the beginning of the end for this particular cycling club as the golf enthusiasts took over.

A number of groups of cyclists seemed happy to form their own cycling clubs and we even had a Preston West End and a Preston East End Cycling Club. Back in 1927 three local clubs decided to merge and form the Preston Wheelers Cycling Club. The newly formed club gained the right to use the town crest as part of its badge and the pre-war period proved to be one of continuous success, with the club holding national records and winning awards.

With the resumption of racing after the Second World War, the Wheelers again took a leading part in the running of cycling in North Lancashire and produced successful teams and individual riders. In recent times the Preston Wheelers have featured prominently in the UK record books thanks to local cyclist Gethin Butler, who later replaced his bicycle with running shoes with yet more success. The Preston Wheelers can be seen gathering monthly near the Withy Trees public house at Fulwood to embark on a ride through the countryside.

Another club near Preston is the Ribble Valley Cycling & Racing Club, which formed in 1951. This club admitted female cyclists in the mid-1950s and welcomed the tandem bicycles too. They created much excitement in 1957 when they introduced the Grand Prix of Preston, an event that went to Leyland and Longridge and up Jeffrey Hill.

Red Rose Olympic Cycling Club is another local group, with members competing in a variety of competitions – be it road racing, cyclo-cross, track or trail. The popularity of the BMX bike

Guild Wheel cycling by Avenham Park, Easter 2014.

has also been embraced with a new BMX racing track on the Fishwick Recreation Ground, which opened in 2006 – a chance for the Preston Piranhas team to showcase their skills.

If you go around Preston you will see plenty of cyclists daily, and through the years they have put pedal power to great use. The pioneering cyclists of Preston Cycling Club served us well and the Guild Wheel promises to keep the popularity growing. The bicycle wheels on the Guild Wheel will doubtless keep turning.

Ribble Valley cyclists hitch a lift at the Preston Guild of 2012.

International cyclists race up Orchard Street in 2013.

Horology – Public Clocks Keep Ticking

Horology, the science of measuring and making timepieces, has long been practised in Preston. Twice a year our attention is invariably drawn towards them: when we perform the annual ritual of changing time as our clocks spring forward or fall backwards one hour. British Summer Time was first introduced over a century ago in 1916 and has continued with only a few exceptions. One being 1940 during the Second World War, when it felt best to leave the time unchanged. Further adjustments followed in 1947 due to fuel shortages. A debate has often

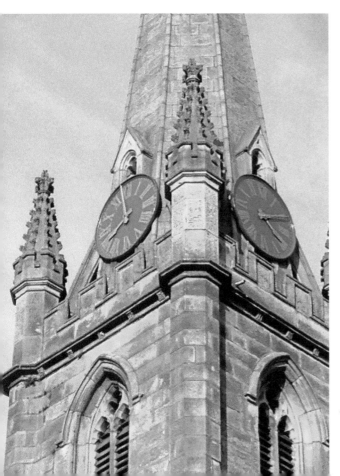

The clock of St Ignatius.

taken place on the matter and an experiment followed from 1968 to 1971 with the UK remaining on GMT plus an hour throughout those years. Nowadays it is the legislation known as the Summer Time Order of 2002 that decrees we change our clocks during the last weekends of March and October.

In this digital age some clocks, watches and computers automatically update. In truth, these days we are less reliant on clocks in public places than our ancestors who, in Victorian times, found them almost a necessity. With that in mind, when work began in the early 1860s planning Preston's new Town Hall (which opened in 1867), one of the requirements was that the clock tower be tall enough so that visitors emerging from the old Butler Street railway station would be able to see the time once they got onto Fishergate.

The congregation of Fishergate Baptist Church also had this in mind when they placed their landmark clock in their tall tower in late 1862. After initial teething troubles this clock was repaired and for almost a century and a half was a reliable recorder of time. The original weight-driven mechanism was replaced by an electric-turret mechanism by Gillett & Johnston in 1974. Sadly, the clock has spent the last few years silently waiting for a clock worker's attention.

As for the clock in the Town Hall tower, it had quite a history before it went up in flames in the fire of March 1947. The chimes of this beloved clock could be heard from afar, with residents of Croston, Bamber Bridge, Catforth, Kirkham and Barton among those who responded to an enquiry in 1937 about the far-reaching sound when the wind direction was favourable. Whenever the clock had periods of inactivity, it caught public attention. One such example was in 1903 when a painter working in the tower had left a can of paint on the mechanism; another was in 1932 when many cotton workers were on strike and it stopped working; also, one year later, a blizzard swept through town and the clock face on the east side was stopped by the weight of snow on the hands.

There was certainly lots of affection for the Town Hall clock, but not so in May 1874 when a correspondent of the *Preston Chronicle* had this to say about our public clocks:

We have a suspicion that no town in the Kingdom, of a similar size, has such a collection of eccentric, irregular public clocks. They are a charming lot, and no mistake. Into their heads have they got it that they have a right either to go or stand – to do as they like, to ignore Greenwich, and to rest and be thankful any time. It is something quite unusual to see the Corn Exchange clock behaving itself properly and keeping good time. Nothing under the sun in the shape of a public clock has such a contempt for order as that sweet horology. Then there is the clock tower of the Baptist Chapel, Fishergate: it has been in a periodically careless and sleepy way – sometimes it goes with fair accuracy; then it bethinks itself that all work and no play is a bad thing, and it stops; and it has been conducting itself in this charmingly incongruous fashion for months. On Monday last the Town Hall clock had a spell of idleness; how not to do it seemed to be the correct thing, so it ceased keeping time for a period. Next day the Parish Church clock followed suit – stood still for several hours, probably considering that it had just as much right to participate in a standing joke as any of its companions. Now, seriously speaking, this is a state of things which ought not exist. Bad going clocks are – so far as time

is concerned – worse than no clocks; and it would be a boom to the town if somebody would either whitewash, or cover up, or pull down, the bulk of our public clocks, or else cause them to go with regularity and accuracy.

The Parish Church – now known as the Minster St John's – was built in 1855 and has a fine clock within the tower. This double-faced clock with dials and chimes was electrified in 1934, meaning electric-driven machinery controlled the striking of the hours and the chiming of the bells. An attractive feature of the minster is its accurate display of the correct time to this day.

The old Corn Exchange clock has certainly stood the test of time and still graces Lune Street. Unfortunately, despite its attractive appearance, the clock hands appear frozen in time. Up until 1967, when the ringway swept part of Lune Street away, two other familiar clocks graced Lune Street. The one above Slinger Army Store had lost its hands by then, but was a reminder of the days when clockmaker Thomas Bennett worked there. The other clock was prominent above Wildings the heating specialists.

Certainly, the jewellers and clockmakers have traditionally provided clocks for public view. One was on view above watchmaker Thomas Yates's old premises on Friargate, another above

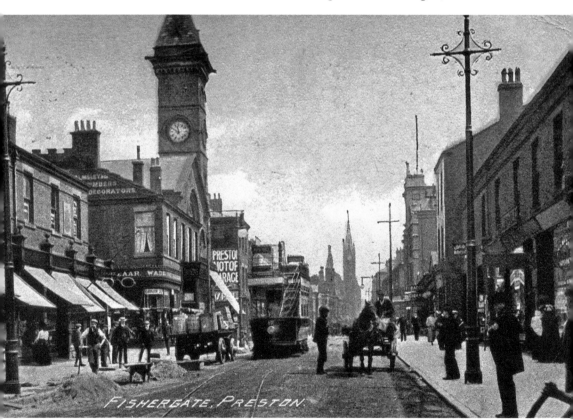

Fishergate with the Baptist church clock and the Town Hall clock in the distance.

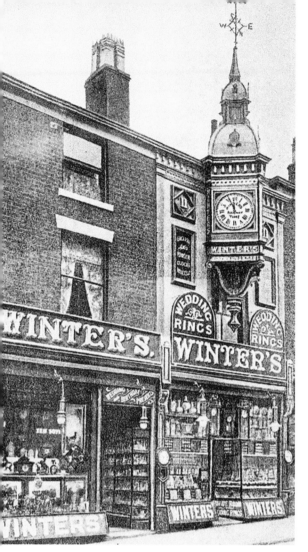

Left: A once familiar Orchard Street clock.

Right: The Fulwood Workhouse clock tower.

H. Samuel's on Fishergate in the 1960s, and a memorable one on Orchard Street above the premises of Winter's – the jeweller's in Victorian days that claimed to keep railway time. If you visited Miller Arcade after the war, Whittles had an art deco clock on public view and recently they have erected a Rolex clock on Fishergate.

Punctuality is key when it comes to transport, and shortly after the new Preston railway station opened in 1880 a clock was installed in the centre of the Fishergate entrance. Happily, this clock and all the digital time displays within the station are keeping time most accurately. Some folk will remember with affection the clock above the old Ribble bus station on Tithebarn Street, the old Preston Corporation Transport clock on Lancaster Road, and the clock at the Fishwick bus terminus down Fox Street. The hands upon the clocks within today's Tithebarn Street bus station are generally reliable, and during the restoration work there they have received tender care.

When they erected the old Preston Docks offices on Watery Lane in 1936, an art deco clock was placed in the square clock tower – a reminder for the dockers to be on time as they passed through the gates opposite. Likewise, there was a fine clock on Stanley Street at the gates of the cotton giants Horrockses and a clock tower stood tall in Strand Road, where hundreds of workers were employed by Dick Kerrs.

Very few public houses have a clock on display outside. One exception is the New Britannia on Heatley Street, which is fixed above the pub sign. Unfortunately, despite having two clock faces, neither show the correct time these days. E. H. Booths, the grocers, have long since left their Fishergate location (where Waterstones now trade), but they did at least leave behind their trademark clock on Glover Street, which still accurately displays the time. In St John's Shopping Centre, a clock is also on display that can be relied upon to accurately tell you the time of day.

The familiar church building on Meadow Street – until 2015 known as St Ignatius and is now the cathedral of St Alphonsa – has had a three-sided clock in the base of its elegant 114-foot-tall spire since early Victorian days. The current clock dates back eighty years, with the Preston clockmaker Mr Green installing the latest electrical clock after removal of the old mechanical timekeeper. Unfortunately, the days of accurate timekeeping seem to have passed since the hands on all three faces are out of time.

At the front of Christ Church on Fishergate Hill, which opened in 1837 and is now part of the sprawling County Hall, there is a large blue-featured clock with a cast-iron interior. It was fixed in 1857 and, according to Anthony Hewitson, a decade later:

> Time has proved how well it can keep time. It is looked after by a gentleman learned in the deep mysteries of horology, who won't allow its hands to get wrong one single second, who used to make his own solar calculations in his own observatory, who gets his time now from Greenwich, who has drilled the clock into a groove of action the most perfect. He his thoroughly master of the clock, and could almost make it stop or go by simply shouting or putting up his finger at it. It is a good clock, however blue it may look; it has gone well constantly; and is likely to continue doing so.

Unfortunately, the master of that clock is long gone and these days, despite its still excellent appearance, we can no longer rely on its timekeeping. Speaking of masters, those controllers of the Fulwood Workhouse, which opened on Watling Street Road in 1868, regarded punctuality as a virtue and a necessity, so a magnificent four-sided clock was placed in the centrally located clock tower. Consequently, residents had no excuse for not returning from their toils in the surrounding fields on time. Sadly, this clock's accuracy also seems to have bowed to old Father Time.

It seems the tradition of public clocks lives on: there has been the recent appearance of a clock above the entrance to the Cotton Court development on Church Street, and another down on the Riversway development outside the revamped Baffitos Waterfront public house.

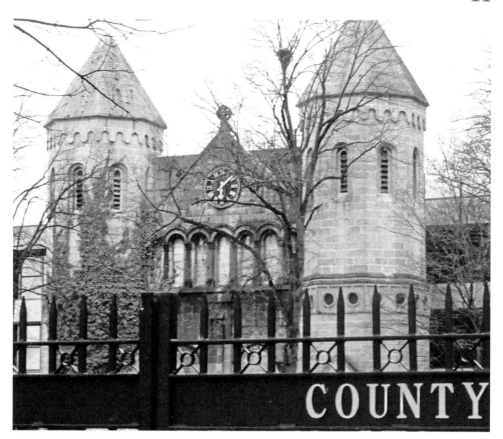

Above: The clock on Christ Church still remains, although it is silent these days.

Right: The clock on the docks at Baffito's – a modern addition.

Illustrations – Furnival Captured Local Life

Illustrations by Furnival were a great feature of the *Lancashire Evening Post* pages from the 1920s onwards. Indeed, if you want a flavour of life in Preston or wider Lancashire in the middle of the twentieth century, then look no further than the cartoons or illustrations by Furnival within the pages of the *Lancashire Evening Post*.

William Cavanagh Furnival, who lived on Liverpool Road, Penwortham, died in February 1966 at the age of eighty-one after a short illness. He had been a widower for nine years and continued to live at his Penwortham home.

His sporting cartoons were a cherished feature of the *Post*'s football and cricket pages, even before he joined the newspaper's regular staff in 1932. He had contributed a weekly cartoon in his spare time from the time of the First World War while he was employed by Dick Kerrs Ltd. His illustrations and witty comments graced many an article concerned with political or social matters. Two striking examples are his drawings that accompanied the series on 'Our Village Churches' and 'Where People Buy And Sell'.

'Tonight's Smile' is a popular series of jokes that appeared in the *Post* on a daily basis and was often accompanied by a humorous Furnival cartoon sketch from the 1930s until the mid-1950s. He was also responsible for the popular children's cartoon 'Togs the Terrier', which appeared from 1933 and made young and old alike chuckle.

Besides covering many notable matches involving Preston North End and other local Football League clubs, he was warmly welcomed at the local non-League football grounds in what was then the Lancashire Combination as well as the cricket venues of Northern League and Palace Shield cricket clubs. Few sporting events didn't draw his attention, with motor racing, boxing, tennis, crown green bowling and curling all getting the benefit of his humour.

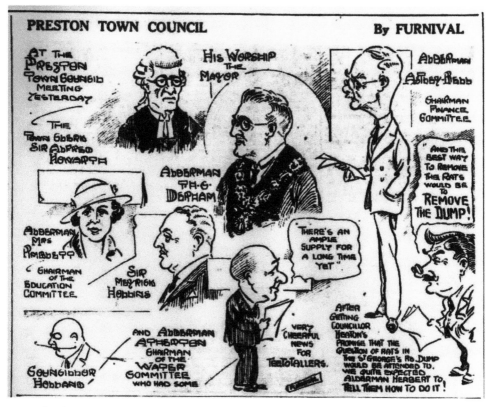

Furnival with Preston Town Council, 1933.

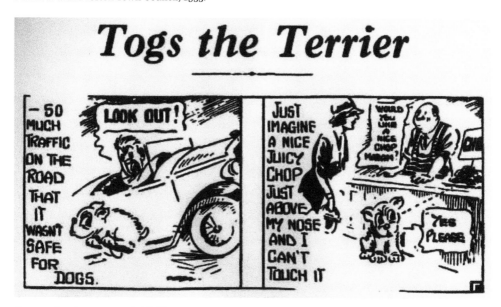

Cartoon fun for young and old alike.

Furnival at Deepdale, 1957.

J

Justice – Let the Jury Decide

The current Preston Magistrates' Court building on Lawson Street was officially opened in March 1972 by the Recorder of Preston, Judge W. H. Openshaw. Sadly, Judge Openshaw was a victim of crime himself in 1981 when he was stabbed to death by John Smith, some thirteen years after sending his killer to prison for theft. The new courts had cost £350,000 and enabled a switch from the old Victorian courts attached to the Earl Street police station.

Three years later it was announced that Preston was set to achieve major Crown Court status, with high court judges sitting in the old Preston Sessions House on Lancaster Road following a £500,000 project to provide five modern courts. In April 1975 it came to pass, with high court judges parading to the parish church for a service to mark the occasion.

Preston's importance within the judicial system was emphasised in 1995 when the current courts complex was opened on the Ringway. Built on the site of the old Saul Street swimming baths at a cost of £25million, it has become one of the biggest centres on the Crown Court circuit. Its opening was marked by a procession of judges, and it is true say Preston Crown Court is very much a part of local life these days. Indeed, it has become a court used for numerous high-profile cases in recent years such as the Bulger trial, the Morecambe Bay cockle pickers' trial and the trial of police killer Dale Cregan.

Besides its own ten courts and two additional courts within the old Sessions House on Lancaster Road, its circuit judges also serve two satellite courts at Lancaster Castle and at Barrow in Furness. Consequently, hundreds of local folk from around Lancashire are being summoned to carry out jury service. The Crown Courts are situated conveniently close to the Magistrates' Court, which remains another busy place of criminal justice, served by trained local people who administer the justice within its walls. There is no doubt that since Preston had city status bestowed, it has developed as a significant centre for administering criminal justice in Lancashire.

However, this was not always the case. Lancaster Castle and its assizes, dating back to 1176, was the place that local folk accused of serious crime went for trial and to learn their fate. The Lancaster Assizes were held twice yearly, and the early nineteenth century had the hangman waiting to dispense justice when the circuit judges departed for their next assizes court. The regular resident Lancaster Castle executioner, Edward Barlow, often had a handful of convicted felons to despatch into eternity for such crimes as highway robbery, forgery and burglary.

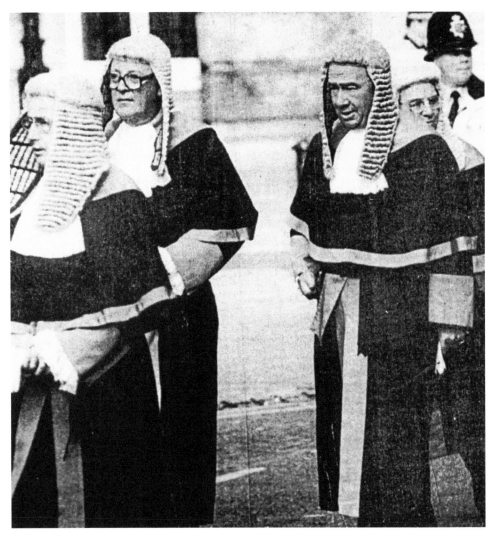

A legal procession: judges on parade.

In 1835 the county assizes were split and Liverpool, then later Manchester, eased the burden on the county town.

By this period Preston was holding regular quarter sessions at the Sessions House, adjoining the House of Correction on Stanley Street. These were presided over by Thomas Batty Addison, the chairman, with local dignitaries carrying out the duties of magistrates. Each case was looked at in its own merits by a grand jury that was made up of respected local gentlemen. A typical calendar at the Epiphany Sessions of 1839 had seventy prisoners for trial from places such as Colne, Burnley, Blackburn and Bolton. The majority of the cases involved stealing – be it clothes, coins, shoes, pocket watches or even a quantity of corn – and the sentences handed out generally ranged from six months in Preston Prison to eighteen months' hard labour within the walls of Lancaster Castle.

This method of justice, with the grand jury deciding whether the accused should proceed to trial with the issuing of a true bill, was abandoned in 1933 when the now familiar committal procedure was introduced. Until more recent times, when Preston Crown Court came to prominence, those accused of serious crimes within the vicinity of Preston were tried further afield.

If you are called up to attend Preston Crown Court for jury service, the chances are that within the fortnight you will find yourself in the jury box and, along with eleven others, have to decide the fate of the accused. Over 2,000 cases pass through the Preston Crown Court each year, with offenders from near and far. A number of trial cases are withdrawn at the last minute, with the accused aware that if they are found 'guilty' by a jury they face a more severe sentence, and so opt to enter a 'guilty' plea in the hope of some clemency.

Preston Crown Court has received many plaudits for its work and efficiency in recent years and a number of local folk have become gainfully employed within its walls. So, if that letter drops through your letter box requesting your attendance for jury service, be not alarmed; instead take the opportunity of seeing the wheels of justice first hand. And take comfort in the fact that while your verdict is critical, you won't be sending anyone to the gallows.

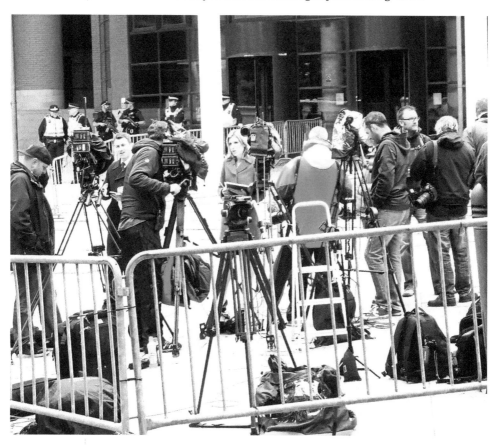

Preston Crown Court in the national spotlight.

Knights – Arise You Preston Knights

Knights may no longer parade in shining armour, yet the prestigious honour of a knighthood is a cherished possession. Occasionally, someone from Preston (or with strong Preston connections) has been deemed worthy of the honour; for example, when James I visited Preston in mid-August 1617, he knighted local man John Talbot and five others.

Of course, in this area there have been many aristocratic families who have had an influence on Preston. Sir Peter Hesketh-Fleetwood was the driving force behind the building of the Preston and Wyre railway, which was crucial in the development of the seaside town of Fleetwood. Sir Richard Hoghton was knighted by Elizabeth I and the Hoghtons down the centuries had an influence on Preston from their Hoghton Tower residence. There is also no doubt that generations of Earls of Derby, of the House of Stanley, had an influence on Preston's society in the days gone by – they even had a stately mansion house on Church Street.

Others who had a political influence on the town and would later receive knighthoods included Sir William Tomlinson, MP for Preston 1882–1906, who was honoured in 1902; Sir Henry Hibbert, a leading figure with Lancashire County Council, whose portrait hangs within County Hall; Sir William Jowitt, a Preston MP from 1929, who was awarded a knighthood after becoming attorney general; and the current Preston MP Mark Hendrick, who was awarded a knighthood in the New Year honours list of 2018, having served Preston since November 2000. Leaving aside these landed gentry or political figures, it is interesting to recall the other local folk who began without the privileges of society yet strove to succeed and earned a knighthood for their accomplishments.

In 1786, during the reign of George III, Richard Arkwright, one of Preston's most famous sons, was knighted. This lad, born in Preston in 1732, developed his spinning frame down Stoneygate and then headed to Nottingham to develop the factory system of production with his water-powered machinery. Who would have thought a lad who worked for a while cutting hair and pulling teeth in Bolton would end up with a knighthood and a magnificent mansion for his home. He died in 1792, leaving his son Richard a vast fortune and numerous spinning factories.

In 1907 Frank Hollins was awarded a knighthood from Edward VII. Born in Stockport in 1843, his association with Preston began when his family acquired the Sovereign Mill. The firm later became Hollins Brothers and, in time, were absorbed into the empire of Horrockses, Crewdson & Co., a business in which he eventually became chairman. They employed 6,000 workers and produced 600 miles of cloth each week. Hollins was a great believer in free trade and was known as

the cotton operatives' friend. Although his Preston residence was Greyfriars, he died at Brignorth, where he was educated as a boy, in late January 1924 in his eighty-first year.

William Ascroft was born in Preston and educated at Preston Grammar School. His father Robert Ascroft was town clerk of Preston from 1852–75. William served his articles with his father and became a member of the solicitor firm Messrs R. & W. Ascroft. He had a knighthood bestowed on him in 1908 by Edward VII in recognition of his lifetime's work in the cause of secondary education, being involved with the Harris Institute for over thirty years. He died in September 1916, aged eighty-four, at Overleigh House in Preston.

In January 1918 a knighthood was awarded to Fernado Harry Whitehead Livesey as a reward for his work with the War Office connected to the admiralty. Born in Spain in May 1860, he was the grandson of the great temperance advocate Joseph Livesey. Sir Harry Livesey was a much sought-after engineering consultant, with many railway, bridge and civil engineering projects overseas guided by him. A lifelong bachelor, he died in 1932 at the age of seventy-two on his yacht, which was berthed in Monaco, and was buried at sea.

When looking for a medical man worthy of great honours, look no further than Sir Robert Charles Brown, who was a Preston physician for sixty-four years. Day trips for nurses and the costs of a new operating theatre were samples of the generosity of one who, in his latter years, local folk referred to as 'Preston's Grand Old Man'. When he received his award from George V in 1919, he was still living in the house in which he was born – No. 27 Winckley Square. He died in November 1825 and his civic funeral at Preston Parish Church grew great crowds of mourners.

In January 1920 George V bestowed a knighthood on Alderman Harry Cartmell, who was at the helm of Preston's civic matters as Mayor of Preston throughout the years of the First

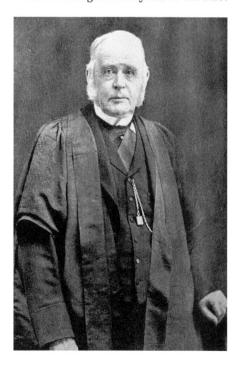

Sir Robert Charles Brown.

World War. Under his guidance local folk played their part in the war effort, enlisting in their thousands to bolster the soldiers needed to fight at the front. He was on hand to take the salute as the regiments departed, and on hand to welcome them back home. Born in Manchester, he first arrived in Preston in 1879 and was admitted a solicitor in 1893. His death occurred in May 1923 at his Goosnargh residence.

In 1927 the folk of Preston had another knighthood to celebrate when Richard Threlfall was duly honoured for his outstanding work as a chemist and engineer. Born in August 1861 he was the son of Richard Threlfall, a well-known Preston wine and spirits merchant from 1816, who built Avenham Tower and resided at Hollowforth Hall. He died in July 1932, in his seventieth year, and his ashes rest at St Anne's Church, Woodplumpton, in the family vault.

In the 1928 Birthday Honours list of George V, a knighthood was conferred upon James Openshaw in recognition of his outstanding public service. Although born in Bury, he was a familiar figure in legal circles in Preston. After practising on the Northern Circuit, he was appointed to the County Judicial Bench and often presided at the Preston Sessions. He frequently lived in Preston during his later years, residing at Starkie House, Winckley Square, although he also owned the Hothersall Hall estate at Ribchester. He died early in 1935 at his Starkie House residence in his sixty-fourth year.

Alfred Howarth, who began his working life as an office boy, was honoured with a knighthood in the New Years' Honours list of 1931 by George V in recognition of his public service. Born in 1867, this son of a Preston iron moulder started work in the Town Hall in August 1880 on a wage of half a crown a week. In the years that followed he studied long and hard to become a

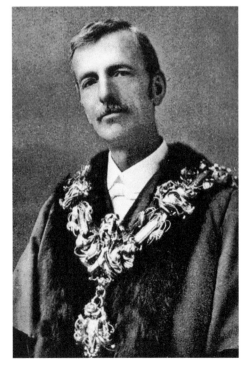

Sir Harry Cartmell.

solicitor and in 1907 was rewarded with the post of Town Clerk. It was a position he held until his retirement at midnight on the day that Preston's new Municipal Buildings were opened in September 1933. He died in January 1937 at his Fulwood home and he was given a civic farewell with his fifty-three years' service to Preston recalled.

In June 1933 the Birthday Honours List of George V included the Recorder of Preston from 1921–28, Ernest. W. Wingate-Saul KC. A former judge of the Preston Borough Court of Pleas and a familiar figure on the Northern Circuit, he later specialised in commercial law. He died, aged seventy-one, in mid-December 1944 when he collapsed on a train taking him from Manchester to his Southport home.

In the King's Birthday Honours list in June 1939 it was a case of following in his father's footsteps, when the son of the late Sir William Ascroft became a Preston knight himself. The honour was bestowed on William F. Ascroft, chairman of Preston Royal Infirmary, and at the time senior partner in the local solicitors firm Messrs R. & W. Ascroft. His title was awarded for his involvement with the preservation of rural Britain and education. He passed away in May 1954, aged seventy-seven, at his Winckley Square home.

John Bagot Glubb, also known as Glubb Pasha, was born in Preston in April 1897. After being educated at Cheltenham College he went on to have an outstanding military career. A veteran of the First World War, where he served in Iraq, by 1930 he was part of the Royal Engineers Arab Legion, which he eventually commanded. He was involved in various legendary desert conflicts until 1956, the same year that he became Sir John Bagot Glubb, Knight Commander of

Sir Alfred Howarth.

the Order of the Bath. He died in 1986 at his Mayfield, East Sussex, home and a service was held in Westminster Abbey in thanksgiving for his life of service.

A more recent local architect earning deserved praise was Sir George Grenfell Baines, the founder of the Preston-based Building Design Partnership. With contracts for universities, libraries, hospitals and numerous other buildings earned by his company, he was soon employing hundreds of people locally. Born in Preston in 1908, he remained close to his roots and was rewarded with a knighthood in 1978 from the Queen. He died in Preston in May 2003, aged ninety-five.

Tom Finney was knighted in the New Year Honours List of 1998 by the Queen. Born in Deepdale in April 1922, he grew up to become Preston North End's greatest ever footballer, earning 76 caps and scoring 30 goals for England. He died in February 2014 and Preston paid tribute to their favourite son, who had maintained his links to PNE throughout his life, giving service as a chairman to the local health authority and on the local magistrates' bench, besides involvement with numerous charitable organisations.

Preston's association with the Openshaw family led to another knighthood link for Preston in October 2005, when Peter Openshaw was knighted upon being appointed a high court judge – his wife became Dame Caroline Swift at the same time. The son of Judge William Openshaw, who was tragically murdered in 1981, he had been Honorary Recorder of Preston since 1999.

It is good to know that from time to time the good, the gallant, or the generous are recognised for their achievements and that Preston can be proud of their connections. The days of knights in shining armour are long gone, but the times of knights are still with us.

Sir Tom Finney.

Lords – The Cotton Lords of Preston

We have had a few Lords of Lancashire, but the so-called 'cotton lords' are probably more familiar to me and you. The cotton lords of Preston came into conflict many times with their employees in the town. In May 1854, the cotton workers of Preston were at the end of the 'Great Lock Out' – a dispute that had begun the previous October and was set to drag on through a cold Victorian winter, continuing until the outbreak of spring. It was, in fact, the costliest and most prolonged struggle that had ever taken place between the employees and their bosses. The firm of Birley Brothers had been at the centre of the argument when their workforce had demanded an increase following over ten years of dissatisfaction.

In Guild Year 1842 the workers had been forced into accepting a 10 per cent reduction in wages; five years later a further 10 per cent was taken from their weekly pay packet. Unsurprisingly, this led to resentment within the town and Birleys employees held a campaign to restore wages to their previous levels. To enhance their cause they began a series of strikes that led to the tightly knit employers demanding that they return to work or the gates would be closed at all the mills in the town. The strikers stood firm and, in consequence, the cotton industry ground to a halt as factory gates were locked. Around 25,000 hands were thrown out of employment and the cry was, 'ten per cent and no surrender'.

There was much sympathy for the Preston workers, with messages of support and financial assistance coming from all over Lancashire. Bands of men, women and children marched through the county's streets singing ballad-style verses and collecting donations for the fighting fund.

The actions of the employers – living a luxurious and privileged existence – were denounced far and wide, and the dispute became a focus of national interest. Before the lock-out began, Thomas Miller, the leader of the Masters Association and one of the town's richest men, was quoted as saying that 'Mastery, not wages was now the central issue'. The weavers' leader, George Cowell, also saw it in wider terms, stating that it was 'a struggle against the tyranny of the cotton lords'.

In consequence, every department of trade was languid with many small traders or shopkeepers in as much a plight as the strikers. Despite the operatives' fund, which reached close to £100,000, the people of Preston suffered through the worst of winter's chill and had barely enough food to sustain them. Such was their situation that they were forced to go cap

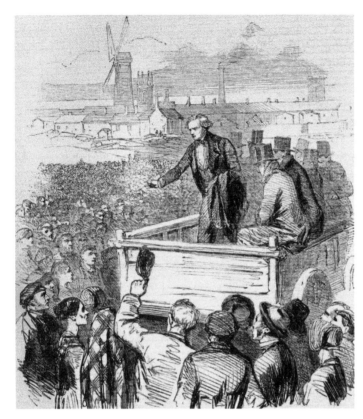

Left: Strike leader
George Cowell spoke
in the Orchard.

Below: Cartoonists
depicted the struggle.

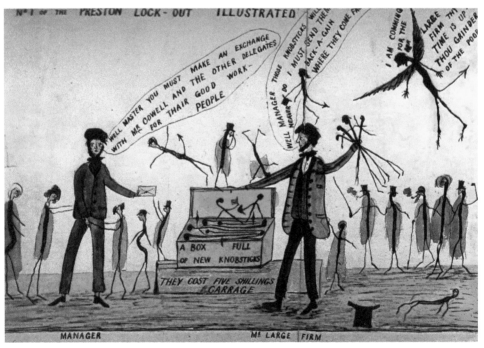

in hand and resume work, as best they could, at this mill or that, on the terms of the masters who had begun to use blackleg labour to get the looms working again. When the mills got back underway on a day in May, there was great sympathy for the workers and the mill owners were cast in a far from favoured light. They claimed the dispute had cost £0.5 million pounds, but they gained little sympathy from the common folk. A number of delegates/leaders of the strike found all the mill gates closed to them and were forced to seek employment elsewhere.

The ballad the 'Cotton Lords of Preston' sums up the feelings of those with sympathy for the downtrodden working classes, with the following choice verses:

Have you not heard the news of late?
About some mighty men so great,
I mean the swells of Fishergate
The Cotton Lords of Preston.
They are a set of stingy Blades,
They've locked up all their Mills and Shades,
So now we've nothing else to do,
But come a singing songs for you.

Everybody's crying shame,
On these Gentlemen by name;
Don't you think they're much to blame?
The Cotton Lords of Preston.

The working people such as we,
Pass their time in misery,
While they live in luxury,
The Cotton Lords of Preston.

Many of the mills had strict rules to be observed by those employed. Such an establishment was that of Thomas Ainsworth & Sons in Cotton Court, off Church Street, where the employees were taught to 'honour their pastors and masters and to obey all those placed in authority over them'. Such was the lot of the cotton mill workers; the cotton lords lined their pockets and poverty reigned on the streets of Preston.

Moor – From Moorland to a Preston Park

In 1834, Preston Corporation enclosed 100 acres of moorland at the northern side of the old town. This land was once known as Preston Moor and had been an uncultivated, rough and heathery kind of terrain. Preston's claim to this land goes back to the reign of Henry III, who granted the moor to the burgesses of the town in 1253. Records show that from 1786–1833 horse racing patronised by Preston Corporation took place on the moor, while the Earl of Derby held races in opposition across the way on Fulwood Moor.

From 1602–1835 pasturage rights were given to the freemen of the town to allow their cattle to graze upon the moor – a rule that was repealed in 1833. When enclosed, the moor was limited to its present dimensions on the eastern and western sides; the northern boundary was Fulwood brook and the southern limit was Ladies Walk, now known as Moor Park Avenue. The park's development was slow for many years, and much of it was used for agricultural purposes and as grazing pasture, with brewer Matthew Brown the tenant of much of it. Only at the time of the Cotton Famine (from 1861), when idle factory hands were used to develop it in return for wages to avert poverty, did the park take shape. Landscaped to the design of Edward Milner, it was opened in late 1867 amid great fanfare. New paths, shrubs, trees, ornamental gardens, an improved Serpentine Lake, bowling greens and cricket pitches all made for a reason to celebrate.

In June 1927, just in time for a total eclipse to be viewed, the newly built Jeremiah Horrocks Observatory was opened. It became a much appreciated place for locals to view the stars above. Although neglected in recent times, the observatory is gradually becoming available to the public again, in the hope of inspiring the next generation of star gazers.

Down the centuries, the park has hosted many significant events. In its early days it was host to the annual Preston Agricultural Show, and the Royal Lancashire Show has also graced its pastures. Military parades have been common and many a big top circus has visited. As recently as 2007 the park played host to the Radio 1 Big Weekend, with over 30,000 attending the free extravaganza. The Preston Guild of 2012, like many of its predecessors, held a number of events on the park.

Some of Moor Park's significant structures have now disappeared. The aviary next to the Avenue, where the peacocks strutted proudly, is no longer there, and water fountains no

Above: Workers from mills and factories toiled to create a park.

Right: The magnificent avenue of lime trees on Moor Park.

longer quench a schoolboy's thirst. By the 1920s there was a grand bandstand built not far from the bowling greens, where many local brass bands filled the air with marching music – although now gone, the melodies linger on. You can no longer take a dip in the chilly waters of the open-air swimming baths, which were opened in 1905 by former mayor William Henry Woods and finally closed some seventy years later. The once popular children's paddling pool on the northern boundary is also long gone. The nearby Serpentine Lake looks refreshed and the promised new bridge will delight many.

It may be hard to imagine, but a century ago, during the First World War, the park became the site of a hospital to care for the war-wounded troops; its ample space was also utilised during the Second World War.

Sporting activity has always been a significant part of the park's life. Older generations will tell you of the battles between local cricket teams, the highlight being the chase for the Turner Cup. This final was often held over three or four evenings and would attract thousands of enthusiastic spectators who ringed the boundary ropes. The winners were local heroes.

Only in 1932 did the highly sought after Pavilion and Café get built, but this was destroyed by fire in 1976. It was replaced by a more functional Pavilion, equipped with showers and changing cubicles. The amateur footballers of Preston can still be seen on the numerous pitches each weekend. Baseball, rounders, hockey and basketball have all been played within the boundaries. Road runners and walkers have circled the park for generations and cyclists have wheeled their way up the Avenue.

If you walk along the magnificent avenue of limes from Garstang Road you will observe a large stone boulder inscribed with the achievements of one Tom Benson, the world's non-stop walking champion, who circled the park's 1.8-mile perimeter for days on end to achieve greatness; Tom Benson Way was named in his honour. Further along the Avenue are the bowling green pavilions that have survived fire and flood to emerge proudly once again. A little further on and you will see the ultra-modern outdoor gymnasium, a children's playground befitting a modern age, and of course there are tennis courts across the way.

Significant citizens of our old town have also had their dwellings along Moor Park Avenue: notable pioneering showman Hugh Rain lived there, as did mill owner William Birtwistle, and William Henry Woods of tobacco factory fame. Nowadays, a number of these fine houses are used by medical practitioners or converted into flats or apartments. Moor Park Avenue is a pleasant place to stroll beneath that green canopy of no less than 179 lime trees of different ages.

The other premises on the dwellings side of the Avenue, close to Deepdale Road, have been all about education. Many folk will tell you of the grand days of the Park School. This grammar school for girls was opened in 1907 and they were joined by the boys of Preston Grammar

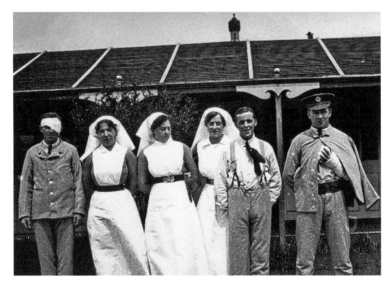

Caring for the war-wounded at the Moor Park Hospital, *c.* 1917.

School, Cross Street, in 1913. After the demolition of the old school in 1957, the stone gateway was transplanted on the Avenue – and there it remains. Both of the cherished schools gave way to a sixth form college under education changes of 1969.

The park is still blessed with two park lodges, one beside the Serpentine Lake and the other in the south-west corner facing Garstang Road, the original homes of Preston park-keepers whose appearance would send mischief-making youngsters scurrying away least they got a ticking off – woe betide them if they stood up on the swings or dropped litter within the park.

No doubt Moor Park is steeped in history and long may local folk enjoy the magnificent pastures that our Parks Department tenderly take care of – enjoy the abundant wild flowers, daisies dancing in the breeze, buttercups in the sunshine and the annual carpet of daffodils along the northern perimeter. The current regeneration work taking place in Moor Park is a sure sign that it remains a jewel in the crown of the city.

Fairground fun for all, 1944.

Making a splash in the paddling pool, c. 1960.

Novelist – When Charles Dickens Came to Town

Novelist Charles Dickens came to town on at least three occasions and there were certainly great expectations when he visited. His trip to Preston in late April 1867 was a resounding success as he enthralled the audience at a packed Theatre Royal. The dress circle, where seats sold for 4s, were filled by many local families of distinction, and the mayor of Preston was among the captivated audience. Throughout his readings, or rather recital, of *Doctor Marigold* and *Mr Pickwick*, he did not once refer to the books before him and his skill in impersonating every character he introduced delighted the gathering.

Invigorated by his performance on that Thursday night and after a good night's rest at the Bull Inn, he decided to walk the 12 miles to Blackburn for his Friday night recital there. Mr Dickens, aged fifty-five, took to the highway along with his agent, George Dolby, who gave instructions for their entourage to go ahead by rail and set up the equipment. According to his agent there seemed little on the route to interest them, the highway lying almost entirely among the smoky factories and mills. It was therefore with some pleasure that around 7 miles into their journey they discovered the picturesque ruins of an old mansion, high upon elevated ground. A local farmer informed them that it was Hoghton Tower, which at that time was falling into decay and had a melancholy air about it. Aware of the history of the building, Mr Dickens obtained permission to roam about the place and lingered for quite some time, soaking up the atmosphere before continuing to Blackburn, where once more rapturous applause greeted his recital that evening.

A few months later, when Mr Dickens was putting the finishing touches to his latest manuscript, *George Silverman's Explanation*, he revealed that his visit to Preston and Hoghton Tower had been an inspiration as he wrote his tale. The manuscript including the following words, 'My parents were in a miserable condition of life, and my infant home was a cellar in Preston. I recollect the sound of father's Lancashire clogs on the street pavement above.'

There were also references to Hoghton Tower, which was portrayed in an exaggerated fictional manner as a crumbling farmhouse building neglected by time, with ceilings falling, plaster crumbling and beams and rafters strewn about the place.

Mr Dickens's first significant visit to Preston took place during the 'great lock out', which began in October 1853 as workers attempted to have pay restored to previous levels. On the

last Saturday of January 1854, Mr Dickens, having heard of the plight of the cotton workers of Preston who had been locked out of their factories, turned up unannounced at a delegates meeting in the old Preston Cockpit, Stoneygate, to observe a union meeting.

The following day, Mr Dickens was present at an open-air meeting held on the Orchard, where delegates from afar were proud to pledge money to the Preston operatives that they may continue their fight. He was clearly impressed by the comradeship of the workers and the orderly fashion in which things were conducted, remarking:

> Neither by night or day was there any interruption to the peace of the streets. Nor was this an accidental state of things, for the police records of the town are eloquent to the same effect. I traversed the streets very much, and was, as a stranger, the subject of a little curiosity among the idlers; but I met with no rudeness or ill temper.

On the Monday, Mr Dickens returned to the Cockpit to see the people paid – piles of pennies were distributed to those in need. This was the time he was writing his book *Hard Times*, which his visit to Preston would influence; his mythical Coketown had many similarities to the Preston of those days. As for the cotton workers of 1854, they grudgingly returned to work poverty-stricken.

The popularity of Mr Dickens's readings led to tours in the USA, Ireland and Scotland in 1868 and 1869. After an extensive tour of Scotland towards the end of February 1869, he had occasion to board the night mail train to London, along with his agent Mr Dolby. According to Mr Dolby, as the train approached Preston an express train going in the opposite direction passed at speed. Unfortunately for Mr Dickens, who was sat by a partially open window, the draught created by the passing train blew his favourite sealskin cap off his head and through the

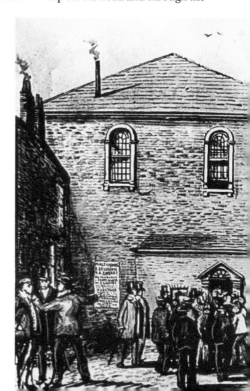

Mr Dickens visited the Cockpit.

opposite window into the darkness. Its loss was greatly deplorable, and when the train halted at Preston station the agent informed the stationmaster of the whereabouts of the cherished cap and offered a reward to any plate layer or workman on the line who should find and return it. When Mr Dickens arrived at Liverpool a week later, there was a parcel awaiting him at the station containing his cherished cap with the compliments of the Preston stationmaster.

By March 1869 Mr Dickens was once more touring England, being contracted for seventy-five readings in town and country for the princely sum of over £12,000 (equivalent to £1.3 million these days) including a percentage of theatre receipts. Unfortunately the strain of the tour taxed his health, which was already troubling him. Fits of dizziness and growing loss of sensation in hands and feet on his left side troubled him greatly. The trouble developed sharply after a public dinner in his honour and a recital at Liverpool during the second week of April, but he carried on. By the third Monday of April 1869 he was appearing at Blackburn, where he gave another astonishing performance. With a couple of days' grace before Mr Dickens's next appearances – at Preston and then Warrington – his agent telegraphed the Imperial Hotel in Blackpool and booked apartments there, so they could enjoy the fresh breeze and sea air. The break seemed beneficial, with Mr Dickens appearing revived and having got his appetite back after two good night's sleep and walks on the sands. Consequently, they set off to Preston on the midday train, having been telegraphed the news that every ticket for his appearance at the Guild Hall that night had been sold out – a total of £200 in box office receipts. The clamour to hear his recital of *Oliver Twist*, featuring Bill Sikes and Nancy, was overwhelming.

When the party reached the Bull Inn, Mr Dickens was handed a telegram from his physician, Mr Beard, saying he was very concerned about his health and was on his way from London immediately. While waiting for Mr Beard to arrive, Mr Dickens and his agent spent their time

Sell-out crowds greeted the novelist.

supervising the setting up of the equipment in the Guild Hall, before walking down to the station to greet the doctor. After walking back to the Bull Inn, Mr Dickens underwent a strict examination at the hands of the medical man.

On conclusion of the examination Mr Beard told his agent, 'If you insist on Mr Dickens taking the platform tonight, I will not guarantee that he won't go through life dragging a foot.' Big tears were rolling down Mr Dickens's face as the news was communicated, and though he insisted he would carry on, his agent and the doctor thought otherwise and he was quietly dispatched to Liverpool and the Adelphi Hotel.

By then the time was 5 p.m. and the cancellation was announced, with money borrowed from Mr Byrne, the manager of the Bull Hotel, so that those who did appear could be recompensed. All efforts were made to make people aware of the cancellation, even Chief Constable James Dunn got involved, sending police officers on horseback to alert folk travelling in on the country lanes of the unfortunate events.

Within days Mr Dickens was on his way to London to be examined by the great physician of the time, Sir Thomas Watson. His conclusion was that he was on the brink of an attack of paralysis – possibly apoplexy – brought on by prolonged overwork. Rest and recuperation were the remedy to restore his health.

Unfortunately, Mr Dickens struggled throughout the next year and his last book, *The Mystery of Edwin Drood* was unfinished when he passed away on 9 June 1870, aged fifty-eight, at his residence Gads Hill Place, near Rochester. The nation mourned the passing of the greatest novelist of the time. So just remember when you take the high road from Preston to Blackburn, Charles Dickens once walked that way too.

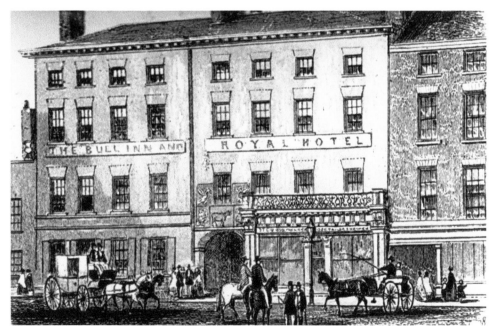

Bed and board at the Bull Inn for Charles Dickens.

Oddie – The Man with the Midas Touch

Oddie with the Midas touch was a phrase uttered in Victorian Preston when reference was made to James Oddie. Back in 1829 James Oddie arrived in Preston from Clitheroe (his birthplace) with his parents, retired innkeeper James Oddie and his wife Margaret. The five-year-old was sent straight away to a Congregational tutor and then attended the Wesleyan Chapel School in Pole Street. At fifteen he ceased schooling and took up an apprenticeship with Clarke's Foundry in Holden's Yard, earning 2s per week.

With four years' experience behind him he became a journeyman moulder, working firstly for an engineering firm in Manchester and then heading for London working on shipbuilding and railway enterprises. Two years later, in 1847, he married Rachel Riding and the ambitious Oddie emigrated to Australia in 1849 along with their young daughter. Once there he bought a half-share in a foundry in Geelong, but was struck by tragedy as his wife and child died from fever within weeks of arrival. Resolving to carry on, he immersed himself in his work and stayed there until September 1851, when reports of gold being discovered led him to leave and head for Golden Point. When Oddie arrived there only a handful of tents were pitched, but that would soon increase as news broke. Working in parties of five, the gold diggers normally mined 30 ounces per day.

After a year of digging gold, the enterprising Oddie took to store-keeping and gold buying, with marked success, and took out an auctioneer's licence. In 1854 he removed from the diggings to the newly proclaimed township of Ballarat, establishing a land and home agency and developing a money-lending agency, which became a deposit bank in time. There were tough times ahead for the gold diggers, who operated under a system of Gold Licences issued by the government of Melbourne.

Frustration due to overzealous licence checking led to the burning down of the Bentley's Hotel, erection of a stockade to deter licence checks, and riots that led to over thirty diggers and six troopers meeting their death as the military and mounted police restored order in what became known as the Eureka Stockade. Oddie counted no less than twenty-two slain diggers within sight of his store, blood trickling from their fatal wounds. One hundred and twenty diggers were arrested and thirteen tried for treason by a Melbourne jury, who found them not guilty. A Bill of Indemnity was passed to cover the alleged wrongdoing of the government and the Ballarat Reform League was formed, leading to changes and miners' rights legislation.

Slight in stature and a popular figure, James Oddie was elected to the newly created municipal council and held the position of chairman for two formative years. The gold rush peaked by 1858, with over 60,000 visitors attracted to the town and some 20,000 permanent residents rich from their diggings established the community. The gold rush days are long gone now, but Ballarat is a major city with industries such as clay, wool, potatoes and meat all contributing to its success.

Over fifty years later, in 1909, Oddie wrote to the *Preston Guardian* with his recollections of those early days and was obviously pleased with the progress of the city of Ballarat. He remarked that up to that year the Commonwealth gold yield had been £574 million and Ballarat had contributed £78 million.

He remembered fondly his early days in Preston when the old and much-liked Samuel Horrocks would daily visit his cotton factories in Church St and Stanley St arriving in his brougham. He recalled also the riotous behaviour at the local elections; agitation over working conditions; the Lune St riot of 1841 by the Chartists; the stage coaches that raced through the town at 6 miles an hour heading for Liverpool or Manchester; the common sight of windmills

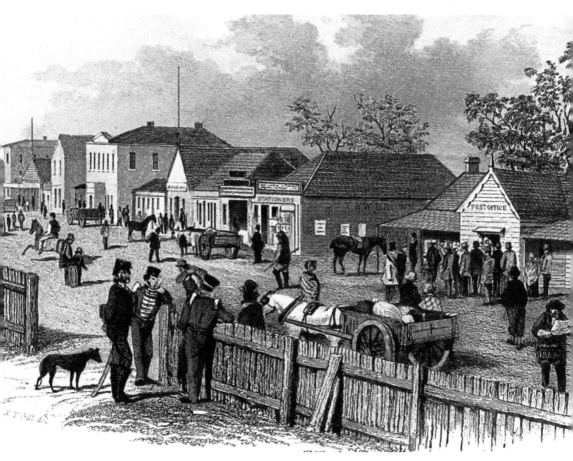

Early days in the gold city, where Oddie made his home.

around the town, especially the one on Moor Lane; the dreaded cholera that visited in 1832 and the first steam train to Manchester in which his father travelled to do business.

Most of all, though, he was full of praise for Joseph Livesey, the great moral reformer who had signed the pledge not to drink alcohol. Oddie had been a disciple himself and had signed the pledge in the theatre at the age of fifteen. He attributed his longevity to that deed, and revealed that a portrait of Joseph Livesey was upon his bedroom wall.

His contribution to the growth of Ballarat was considerable and the Oddie Gallery recalls his contribution to the Ballarat Fine Art Gallery (established in 1884), and a Victorian observatory carries his name.

The Preston-taught scholar who went on to fame and fortune in Australia was a devout Wesleyan Methodist throughout his life. He took a second wife, Mary, but she died in 1884. When Oddie died in 1911, aged eighty-seven, he had no direct descendants. In his last communication with Preston he had declared: 'Hurrah for proud Preston and its folk of mental and moral nobility.'

James Oddie had fond memories of Preston.

P

Pediments – All Greek for Us

Pediments can be found above many buildings, in particular classical Greek temples, and the Harris Museum, Art Gallery & Library owes some of its magnificence to that architectural trend. Besides the numerous treasures within, the building itself is quite wonderful to behold. It officially opened in 1893, and great attention has always been given to its upkeep and restoration.

I must admit that the Market Square view with the pediment above the gilded letters has always had my admiration. As for the group of sculptured figures, I have just been content to acknowledge there is something Greek about them. However, while delving in the LEP archives recently I came across an article from 1933 – some forty years after the Harris opened – and their significance became clear to me. This is what the correspondent 'North-Westerner' had to say:

> The pediment – that was completed in 1888 – with its great group of statuary, of heroic size, is acknowledged to be the crowning ornament of the building. The statuary under the tympanum of the pediment is designed to illustrate a discussion concerning the erection of the Parthenon at Athens, between the great statesman Pericles and his illustrious contemporaries. On one side of Pericles, the philosopher Anaxagoras holds a scroll showing the word 'Nous' (Intelligence). Next to him, Letinus, the chief architect of the Parthenon, displays the plan of a temple. Leaning forward on the opposite side of the dais and supporting a shield is Pheidias, the greatest of all the Greek sculptors.
>
> Grouped near the central dais three philosophers, Parmenides, Zeno, and Socrates are shown in close discussion and in the angle of the pediment Thucydides reclines in meditation over the manuscript of his history of Greece. Famous Hellenic poets and dramatists are grouped on the other side. Pindar with a lyrical ode to a victor in the Hellenic games, Aeschylus brooding over the fate of Athens, Sophocles and Euripides discussing the art of the ancient world, Herodotus resting, staff in hand, with his finished historic works. A youthful Victor in the games appears in the group, balanced on the opposite side by prancing chariot horses, symbolising the Greek love of sport and athletics.

The sculptor of this striking conception, known as *The Age of Pericles* was Edwin Roscoe Mullins (1848–1907) from London. Born in London, Mullins was the son of a solicitor. He initially studied at the Lambeth School of Art and spent time at the Royal Academy and in

Pericles takes centre stage in the Harris pediment.

The magnificent Harris building viewed from the Market Place.

Munich perfecting his skills. Among his numerous distinctive works are a statue of the poet William Barnes in Dorchester and a statue of Queen Victoria in Port Elizabeth, South Africa, which was unveiled in 1903.

Thanks to the great imagination and creativity of Alderman James Hibbert, the architect of the Harris, and those he consulted, we can now raise our eyes in the Market Place to see such exalted figures. In my ignorance I never realised that Socrates was looking down as I walked across the Market Place.

Somehow the pediment seems apt for a place where there are treasures of the past, scientific wonders galore, literature aplenty, works of art, history and modern technology all available to you once you step inside. I am sure that great thought and planning will go into any forthcoming changes as the Greek philosophers would expect.

Queens and Kings – When Royalty Came to Town

Queens and kings have, down the centuries, ensured that Preston's links with royalty are strong and our ancient borough has been visited by royalty on many occasions. In July 1306, Edward I stayed a few days before leading one of the most powerful armies ever seen in Lancashire on their way northwards. Edward III halted in Preston for a while as he recruited forces to trek to Scotland, where he was ultimately victorious at the Battle of Halidon Hill, during which 4,000 Scottish warriors were slaughtered.

On 15 August 1617, a grand banquet was held in the old Moot Hall to entertain James I, and the dignitaries of the day knelt before the king in the Market Place. Charles II passed through Preston in 1651 on his way to do battle at Worcester as he fought to restore his birthright, although it would be almost another decade before he regained the Crown. During the Royal and Parliamentary conflicts in the seventeenth century and the rebel antagonisms of the eighteenth century, Preston was the scene of a number of skirmishes and various forces held the town in their grip.

Only in the nineteenth century did we start to have the kind of royal visit we enjoy today. In September 1803 Prince Frederick William, a nephew of George III, came to town to review the Preston Volunteers and stayed at the Bull Hotel. A year later his father, the Duke of Gloucester, accompanied him on a further visit, on which occasion the prince declared that Preston was 'the handsomest town in England'.

In late September 1847 Queen Victoria passed through the town after visiting Fleetwood. Five years later, in October 1852, Queen Victoria and Prince Albert lunched at the railway station. It was a formal occasion with over 1,000 local folk there to greet the royal family. It must have been a pleasant royal experience because twelve months later the royal entourage had a fifteen-minute break to partake of lunch once more. Alas, Queen Victoria never made an official visit to the town and as her royal train passed through the station on its way to Balmoral, the carriage curtains were often drawn.

In October 1859 the Fulwood Barracks was visited by the queen's first cousin Prince George William Frederick Charles, the Duke of Cambridge, where he inspected the troops. He returned again in October 1867 when he walked in procession to the new Town Hall, which he declared officially open. In the middle of October 1869 the Prince of Wales, the future Edward VII, had

an informal stop at Preston railway station on his way from Balmoral to Chester, walking about the place for around twenty minutes smoking a cigar. The Duke of Cambridge obviously remained popular with Preston folk because he was also invited to the Preston Guild of 1882, on which occasion he laid the foundation stone of the Harris Free Library.

The Prince of Wales made an official visit in July 1885 when he laid the foundation stone of the Preston Dock. Seven years later in 1892 when the Dock was officially opened there was much fanfare as Prince Albert, the Duke of Edinburgh, arrived to carry out the duty.

Queen Victoria died in 1901 and Edward VII, after whom the Preston Dock had been named, took over the monarchy. He was followed in 1910 by his son George V, whose only visit to Preston came in 1913. Besides the usual greetings at the Town Hall the king, along with Queen Mary, was given a conducted tour of the Horrockses cotton mill after having lunch at the Bull & Royal Hotel. In 1920, Prince Albert – the future George VI – also paid a visit to the mill. In 1921 and again in 1927 the then Prince of Wales, the future Edward VIII, toured the North West of England and was given a royal welcome by the folk of Preston on both occasions.

Just a year after their coronation, George VI and Queen Elizabeth went on a tour of Lancashire. On 17 May 1938 they were welcomed at the Town Hall in Preston for a civic reception. The part played by Preston's brave citizens during the Second World War was acknowledged just two months before the war ended in 1945, when the king and queen returned once more to the town.

In 1949 the Princess Elizabeth accompanied by her husband the Duke of Edinburgh was a welcome visitor, dining at the County Hall in Preston and giving a friendly wave to the crowds that gathered in front of the fire-damaged Town Hall. A couple of years later, in 1951, we had another visit from her father, George VI, along with Queen Elizabeth and the Princess Margaret on their way to inspect the king's duchy of Lancaster estates.

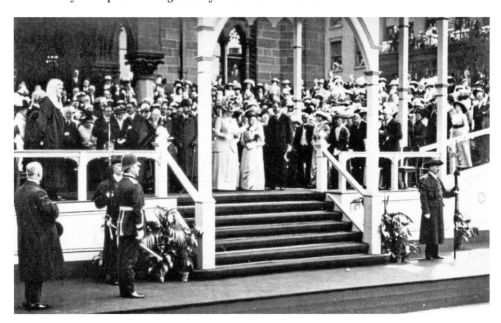

The royal visit of George V and Queen Mary, July 1913.

 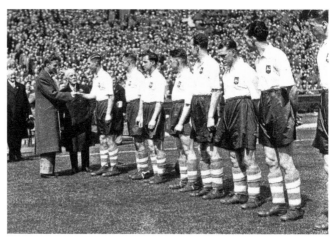

Left: A royal visit in March 1945.

Right: Wembley greeting from George VI in 1938 for PNE's FA Cup-winning team.

There was much excitement in 1955 when it was announced that the newly crowned Elizabeth II was to visit Preston along with Prince Phillip, the Duke of Edinburgh. Crowds gathered on the railway station platform to wave and cheer as she stepped from the train. A radiant queen and a smiling duke were given a welcome as sunny as the April weather, with thousands lining the route to catch a glimpse of the royal couple as they toured the town in an open-top car.

In 1977 as Elizabeth II celebrated her Silver Jubilee she visited the town again, accompanied by Prince Phillip. The mayor of Preston, Councillor Joseph Hood greeted the queen as she arrived at the Town Hall and the gathered crowds gave her a warm welcome. Her Majesty was back in town two years later in 1979 to unveil the ancient obelisk that had been restored to its rightful place in the Market Square. Much to the delight of those gathered, the queen had a walk around and a friendly word with many who had waited for a chance to catch a glimpse of her on a damp and dreary day.

Preston was beginning to feel quite privileged when the queen returned once more in 1980, as part of her tour of the duchy of Lancaster estates. In June 1983 there was even more excitement when Diana Princess of Wales came to Preston to officially open the Royal Preston Hospital.

Of course, the crowning glory for Preston came in the fiftieth year of Elizabeth II's reign, when she made the town the fiftieth city in England. In fact, the queen, accompanied by Prince Philip, ended her three-month-long Golden Jubilee tour on 5 August 2002 at Preston, confirming the city's new status.

Most recent royal visitors have included the Princess Royal, who made a fleeting visit to our city, and Her Majesty the Queen was once more in our midst when she visited the troops at Fulwood Barracks. So it seems that down the years Preston has been blessed by numerous royal occasions and has generally responded with delight to having royalty within our midst.

All smiles for Elizabeth II in June 1977.

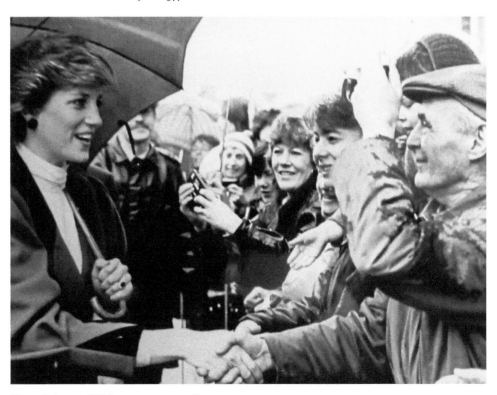

Diana, Princess of Wales gets a warm welcome.

Railways – On the Right Tracks

Railway volunteers have ensured that on the Riversway development we have a reminder of the glorious days of steam. The opening of the Ribble Steam Museum in September 2005 was most welcome in the area where the old dock railway began service over 170 years ago.

From early Victorian times Preston has been at the heart of the country's railway network, with lines converging from east, west, north and south. The first railway in these parts was the one connecting Preston from its Butler Street station with Wigan, which was opened on the last day of October 1838 and involved the building of the North Union Railway Bridge over the River Ribble. Two further bridges to cross this river would follow in the coming years, the East Lancashire Railway Bridge opened in 1850 and incorporated a footbridge ideal for watching trains go by, followed in 1882 by the West Lancashire Railway Bridge that carried rail traffic to a new station at the foot of Fishergate Hill.

In fact the coming of the railways had a significant effect on the Preston landscape. At the beginning of May 1840 the Preston to Longridge Railway was opened with its terminus being initially behind Stephenson Terrace in Deepdale, prior to a tunnel being constructed under Preston to take the line to Maudland. In June of the same year the town was connected with Lancaster, followed weeks later by the opening of the Preston & Wyre Railway between Preston and Fleetwood, which had involved the construction of the viaduct at the bottom of Tulketh Brow.

By February 1846 Preston and Lytham were united, and soon afterwards railway communication was established with Blackpool and Blackburn. In the same year the Ribble Branch Railway, connecting Preston Quays with the Butler Street station, was completed. By this time the first railway to Wigan had led to a link up with Bolton via the Euxton Junction and ultimately a link with Manchester, where in 1830, amid great excitement, that place had been connected by rail to Liverpool. Add the Preston to Liverpool line in 1849 and a connection with Southport via Burscough Junction six years later and the folk of Preston were almost spoilt for choice – seaside, country and cities were now just a train journey away. In later years more direct routes to Blackpool and Southport would also follow.

The railway certainly prospered during those Victorian days, and as more travellers ventured from London to Scotland the need for overnight accommodation was met by the building of the Park Hotel, overlooking Miller Park. The hotel was ready for its first businessmen by Guild

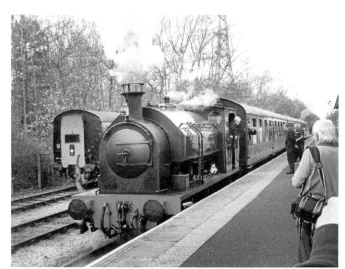

Full steam ahead on the Ribble Steam Railway in 2016.

Down on Preston Docks, 1938.

Week 1882, having cost £40,000 in construction and with the approach to the hotel from the railway station being across an elevated covered walkway.

The increased rail traffic also meant an upgrade for the Butler Street railway station was essential; it had been described by historian Anthony Hewitson as one of the most dismal, dilapidated, and disgraceful structures in Christendom. Formally opened in July 1880, the new station and a new bridge over Fishergate had cost £250,000 to build. Preston was at last able to cope with a railway system that saw 450 trains – passenger and goods – arrive or depart every day.

In the early days of the Preston to Longridge line, which had stations at Deepdale and Maudland, the carriages were drawn from Preston to Longridge by horses. On the return journey, owing to the downward gradient, the carriages ran by their own momentum as far as Grimsargh station, from where horses were employed once more. Not until June 1848 was that train hauled by a steam engine, this being named *Addison* in honour of the chairman of the rail company, Thomas Batty Addison.

Forty years on and a private branch line from Grimsargh to the asylum at Whittingham was laid. This was operated for seventy years until June 1957, taking 12,000 tons of coal to the hospital each year and transporting 200 staff to Whittingham each day. Another rail closure to

hit Preston was announced in September 1963 when the controversial Beeching Plan included the closure of the direct Preston to Southport line – due to low passenger numbers and losses exceeding £120,000 per year.

In September 1960 there was drama north of Preston station in Croft Street at the locomotive sheds, essential for the maintenance of the regions locomotives. That day one of the town's biggest blazes saw the sheds gutted by fire, with twelve locomotives destroyed. The fire sounded the death knell for the sheds, where thirty engines were normally based, with operations being transferred to Lostock Hall.

Of course the days of steam engines were numbered and gradually they were taken out of service, much to the despair of train-spotting enthusiasts who had clambered onto the wall at Pitt Street to see the engines steam past. In February 1958 rail passengers on the Preston to Blackpool line were able to have a taste of things to come when borrowed diesel unit trains were used to transport them to the seaside. It was a chance to sample the power of diesel motive units; after all, back in Preston in 1955 the English Electric works manufactured the prototype of the high-powered Deltic diesel locomotive for use on the East Coast main line from 1961.

Soon diesel locomotives would be operating on the London–Glasgow line through Preston, and by July 1973 the electrification of the main rail route was complete. August 1968 had seen the last weekend of regular steam working on the British railway network. The days of steam may have long gone, but occasionally a nostalgic steam engine passes through on tour and Preston remains very much a significant place on the rail network of today.

The East Lancashire (foreground) and North Union Railway bridges over the River Ribble – a railway legacy.

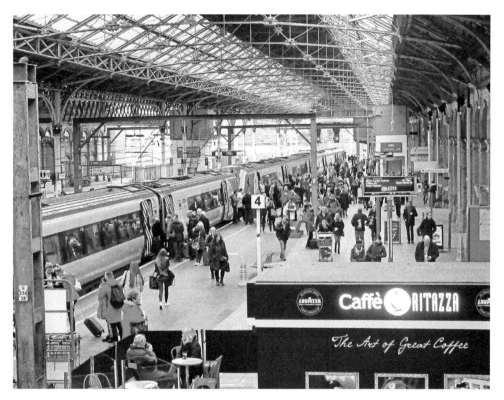

A busy Preston station today.

Tornado visits Preston station – the latest steam engine.

Seven Men of Preston

'Seven men of Preston' is a phrase you may well have heard and, like myself, wondered who they were. To understand the significance of the phrase we have to go back to 1 September 1832, when a gathering of local folk took place in the old Cockpit on Stoneygate. It was a special meeting of the Preston Temperance Society to discuss the issue of total abstainers and moderate drinkers of malt liquors. In the quaintly furnished amphitheatre, dimly lit by tallow candles, Joseph Livesey read his draft of the new total abstinence pledge and exclaimed, 'Whose names shall I put down?' Nine days earlier Livesey and John King had met in Livesey's cheese shop in Church Street and drafted the pledge committing their lives to total abstinence.

The historic pledge was signed by seven men, and thus the great teetotalism movement was born. The seven who signed were John Gratix, Edward Dickinson, John Broadbelt, John Smith, Joseph Livesey, David Anderton and John King. The example set by these trail blazers was soon followed by thousands more, with 4,000 pledgers by 1834 in Preston alone.

In truth, the contribution of the seven was significant, but of them it was mainly Livesey and King who rose to prominence locally. Richard 'Dicky' Turner would be credited with coining the phrase 'teetotal' after becoming a loyal follower of Livesey. He was a zealous companion of Livesey's, even marching to London for the cause. The British Temperance League was on the move throughout the land and almost 1,000 temperance societies were formed in Great Britain, with a membership of over 300,000.

Noted campaigners in Preston would include Thomas Swindlehurst, who was publicly crowned as 'King of the Reformed Drunkards'; James Tearle, who was described as a fearless advocate; John Finch, a close friend of Joseph Livesey was dubbed the 'King of Teetollars'; Henry Anderton became known as the 'Temperance Poet' due to his lyrical speech; Edward Grubb possessed a natural gift of oratory; while Joseph Dearden, George Toulmin and Thomas Walmsley all added youthful exuberance and maintained their belief throughout life.

There was always great interest in the original seven men, and upon the death of Joseph Livesey in September 1884, in his ninety-first year, he received glowing tributes in the national newspapers of the day. After all, he had produced many tracts and publications, including a newspaper called *The Struggle*, and been honoured at the Crystal Palace in 1882 to celebrate fifty years of the temperance movement.

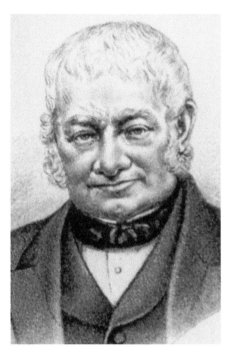 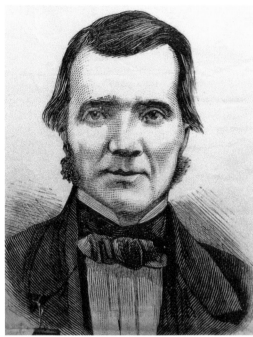

Left: Joseph Livesey led the way.

Right: John King gave support.

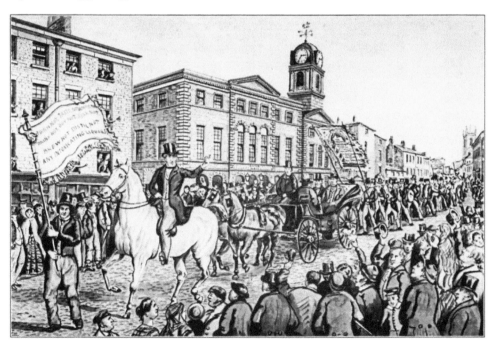

The Temperance procession of 1833, led by Richard Turner.

The pledge signed by the Seven Men of Preston.

In January 1885 his fellow pledger John King, who was a clogger by trade but for many years was stationmaster at Ainsdale, near Southport, died at the age of ninety. In December 1887, John Gratix, by trade an iron founder, made the newspaper headlines being the last of the Seven Men of Preston to die. He was in his seventy-ninth year and still living in Preston.

In Preston Cemetery there is a tall monument, erected in the 1850s, that commemorates the achievement of the men who committed themselves to 'total abstinence from all intoxicating liqour'. And to mark the centenary of the pledge in 1932 a commemorative service was held there and a crown of laurels was placed before it.

Did the efforts of those temperance pioneers bear fruit? Well, a century later, in 1932, it was recorded that out of a population of 126,000 there were only fifty-one people prosecuted for drunkenness, and twenty-six of those were from out of town. An excellent record, according to Chief Constable Ker Watson, who stated: 'I consider Preston to be one of the most sober town's in the country, people are becoming much more sensible over the question of drink.'

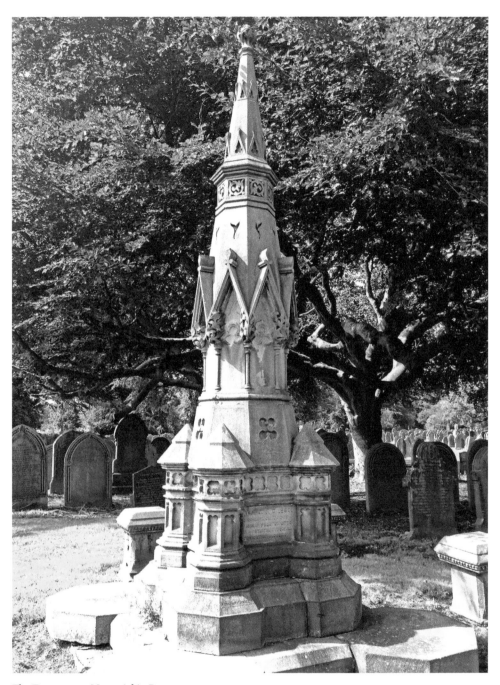

The Temperance Memorial in Preston cemetery.

Telephone – Hanging on the Telephone

Telephone communication methods have certainly changed in recent times with the arrival of mobile and smartphones. Consequently, it is hard to imagine the euphoria felt in Preston in August 1881 when the first telephonic exchange was opened in town by the Lancashire Telephonic Exchange Co., who operated from premises on Lancaster Road, across from where Miller Arcade now stands.

Local enthusiast George Sharples, a chemist by trade but familiar with telegraph engineering, successfully applied for a licence to operate from his premises at No. 7 Fishergate. His Telephonic Exchange opened a few weeks later, having recruited local businesses who at first were reluctant to move away from the highly efficient telegraph message services and embrace the new technology.

Both exchanges gradually expanded their business and by June 1882 George Sharples had a list of some eighty subscribers, including the Tithebarn Street Fire Station, the Town Hall, the House of Correction and the Preston Royal Infirmary.

Things progressed quite rapidly after that and by 1886 Sharples had sold his business to the county operators, who in turn were taken over by the National Telephone Company in 1889.

George Sharples – a pioneer in Preston.

PRESTON TELEPHONIC EXCHANGE.

G. SHARPLES, PROPRIETOR,

(OPPOSITE THE TOWN HALL).

Subscriptions, £8, £10, and £12 per annum.

JUNE 1st, 1882.

36 Alison, Mr. (County Treasurer)	36 Johnston, Mr. H. W. (County Auditor)
2 Ascroft, Messrs. W. & A., Solicitors, 4, Cannon Street	36 Jolly, Mr. T R. (Secretary Blind Institute)
3 Atherton Bros., Messrs., Hanover Street Works	
3 Atherton, Mr. W., Sunnyside, Fulwood Park	
	17 King, Dr., Royal Infirmary
25 Barber, Mr. E., Fishergate Hill	60 Kerfoot, Mr. P., 32, Fishergate Hill
38 Bateman, Mr., Fulwood Workhouse	60 Kerfoot & Co., Messrs., House Furnishers, 93, Fishergate
59 Blind Institute, Glover's Court (T. R. Jolly, sec. Fishergate)	
6 Booth and Co., Messrs. E. H., Grocers and Wine Merchants, 4, Fishergate	65 Lightbourne, Dr., Winckley Square
4 Brown, Dr., 27, Winckley Square	
5 Brown and Deighton, Messrs., Oil Merchants, 33, Shepherd Street	31 Margerison & Co., Messrs., Soap Merchants, Leighton Street
7 Brown, Mr., Engraver, 9a, Fishergate	47 Miller, Mr. N., Avenham Colonnade
39 Bull and Royal Hotel, 141, Church Street (Proprietress, Mrs. Clark	46 Miller, Mr. N., Dentist, 11 & 12, London Road
27 Butler, Messrs. P. and Sons, Corn Merchants, 80, Back Lane	26 Moon, Mr. J., West Cliff
	28 Moore, Messrs. W. F. & Sons, Accountants, 9, Chapel St.
	40 Myres, Veevers, and Myres, Messrs., 15, Chapel Street
37 Cook & Oakey, Messrs., Coal Merchants, Ribbleton Lane	
14 Copland, Mr. M. B., Pole Street Mill	
15 Copland, Mr. M. B., West Cliff.	11 Paley, Mr. G., 15, Ribblesdale Place
36 County Auditor (Mr. H. W. Johnston)	10 Paley, Messrs. W. and Sons, Bank Top, Hopwood Street, and Primrose Mills
61 County Court, Winckley Street	53 Parker, Mr. W., Woodlands, Garstang Road
36 County Offices, Fishergate	24 Pateson, Mr. R., Electrician, &c., 8, Cross Street
36 County Treasurer (Mr. Alison)	49 Potter, Mr., Livery Stables, Red Lion Yard
	50 Potter, Mr., Contractor, 21, Great Shaw Street
62 Derham, Dr., 1 and 2, Albert Terrace, Garstang Road	43 Powell, Son, and Co., Messrs. T., Moor Lane
44 Dewhurst, Mr. T., Preston Permanent Building Society, Theatre Buildings, Fishergate	26 Prudential Assurance Offices, Lune Street
33 Dixon, Mr. G., Union Offices	
	32 Robinson and Sons, Messrs. Rd., Wine and Spirit Merchants, 3, 4, & 5, Avenham Street
36 Easterby, Mr. R. F., Secretary Royal Infirmary	
	36 Sadler, Mr. C. H. (Deputy Clerk of the Peace)
18 Fire Brigade Station, John Street	66 Sessions Court (House of Correction)
17 Forrester, Dr., Royal Infirmary	35 Sharples, Mr. G., Bank House, Latham Street
38 Fulwood Workhouse	34 Sharples, Mr. G., Chemist and Druggist, 7, Fishergate
42 Fylde Road Spinning Co., Water Lane	35 Sharples, Mr. C. H., 21, Latham Street
	64 Sumner, Mr., Brewer, &c., Prince Albert Hotel, Fulwood
19 Garner, Dr., 18, Winckley Square	
13 Gas Company (Head Office, Fishergate)	
48 Goodair, Col., Ashton Park	21 Town Hall
48 Goodair, Messrs. J. & Sons, Peel and Brookfield Mills	45 Turner and Son, Messrs., Solicitors, 12, Fox Street
67 Greenall, Mr. C., Printer, &c., 10, Cannon Street	
41 Green Bank Railway	
	33 Union Offices, Lancaster Road
	25 Walmsley and Co., Messrs., Painters and Decorators, 82, Fishergate
1, 12, 16, 58 Harding and Co., Messrs., Lune Street	30 Walmsley, Mr. P., Drysalter, &c., Aspinall Street
29 Hillidge, Mr. J., Fish and Ice Merchant, Fishergate	23 Whitehead, Mr. J., Ironmonger, 9, Fishergate
8 Horrockses, Miller, and Co., Messrs. (Yard Works)	61 Whiteside, Mr. James, County Court, Winckley Street
36 Hulton, Mr. F. C. (Clerk of the Peace), Fishergate	22 Wilding Bros., Messrs., Alexandra Mill
61 Hulton, Mr. F. C., County Court, Winckley Street	20 Wilding and Sons, Messrs. S. B., Painters, Decorators, &c., 17, Lune Street
17 Infirmary Royal	36 Wilson, Mr. Thos., Solicitor (Messrs. Wilson & Hulton)
9 Irvin and Sellers, Messrs., Peel Hall Works	

The Preston Telephone Directory of 1882.

Within a year the £9 subscription rate offered by Sharples had increased to £12 – a familiar tale! Within three more years the NTC had set up their telephone exchange in Guildhall Street and a decade later shifted operations to the old Preston Gas Co. offices in Glover Street, where the multistorey Avenham car park now stands.

Despite the NTC being taken over in 1912 by the Post Office, the Preston Telephone Exchange remained at the Glover Street premises until 1931, when an automatic telephone system was installed in the General Post Office building in the Market Place. Subscribers had the freedom to directly dial most calls themselves. At the official launch of the new system it was stated that 15,000 calls were dealt with by Preston every day of the week. Not long afterwards the now-familiar row of red public telephone kiosks appeared along the side of the GPO on Market Street and brisk business followed.

From the mid-1940s the increase in telephones was dramatic, with modern technology and underground cables leading to great efficiency. A reflection of the progress was seen locally in June 1964 when the main Preston Telephone Exchange was moved to the purpose-built structure on Moor Lane. By 1980 two out of three homes within the Preston telephone area had a telephone installed.

As for the iconic row of red telephone kiosks on Market Street, they have now almost been abandoned, but there is talk of using them for other purposes – a reflection of modern communication methods.

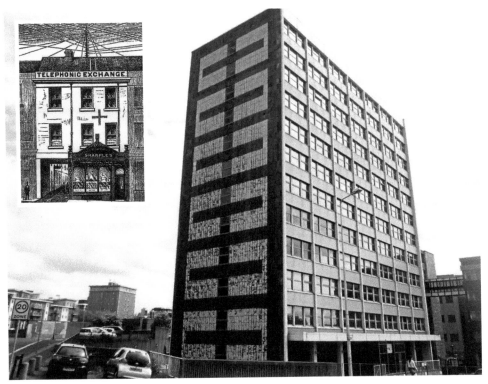

The Moor Lane Telephone Exchange opened in 1964. *Inset:* The Sharples Telephonic Exchange of 1880.

U

Umbrellas and Stormy Days

In his book *Watery Preston*, Paul Godkin began his script by referencing the little umbrella shop on Orchard Street with the sign above its window that predicted 'we shall have rain'. There is certainly some truth behind that sign as Preston has had its share of floods, downpours, storms and showers down the centuries.

One such day was the last Monday in May 1865, when a great storm of thunder, lightning and torrential rain left Friargate and Lune Street awash. Or the days of late November 1866 when the floods led to great destruction of property and the loss of lives, with the River Ribble bursting its banks at Walton, Salmlesbury and Penwortham Holme. Three years later, on a Sunday morning in November 1869, a deluge led to the Ribble overflowing again – the area around Penwortham Bridge was particularly hit, with many boats washed away and the surrounding fields flooded.

The umbrella shop on Orchard Street predicting rain, 1981.

A terrific thunderstorm in early August 1893 led to flooding and damage to property in the town centre with pots and pans floating about in the hardware stores. Lightning caused a serious fire in Mr Myerscough's provision shop in Church Street, and production was halted at Margerison's Soap Works as the ground floor was flooded.

In early November 1904, it was reported that heavy rains brought down tremendous freshet in the River Ribble, and it was quite obvious after 10 p.m. that evening that, with a night tide of over 28 feet, there would inevitably be a flooding of the Broadgate district of Preston. Shortly before midnight the water came over the riverbank and streams poured down all the thoroughfares adjacent to Broadgate, with many homes and cellars flooded.

In October 1927 Preston did not escape unscathed during the night of terror when gales and floods hit the county of Lancashire. There was extensive flooding at Preston Docks and on Broadgate they reported the worst flooding for twenty years – the whole length of the road was covered with water to a depth of 6 or 7 feet.

In mid-December 1936, Preston had to endure hurricane-force gales, torrential rain and severe flooding. Hundreds of acres of land were flooded as a result of the River Ribble overflowing its banks. Roads and railway lines were submerged and in Avenham Park one of the buttresses of the wooden Tram Bridge was carried away, causing a portion of the bridge to sink when a cabin crashed into the foundations. Both the Avenham Valley and Miller Park took on a lake-like appearance.

A decade later, in September 1946, continuous heavy rain caused much chaos and the fire brigade had to attend to twelve flood calls at mills, workshops, public houses and shops. Bus services were abandoned as roads became impassable.

In mid-January 1954, the wettest January day since observations began in 1876 was recorded: it had a twenty-four-hour rainfall record of 2.25 inches. Quite naturally, there had been flooding in Walton-le-Dale as the River Ribble overflowed. Mind you, Preston's previous highest recorded days of rainfall remained at 2.82 inches in May 1920, and 2.57 inches in August 1907.

It seems the odd flood or deluge is never far away. Some people will recall the floods of November 1977 when folk went rowing on the Penworthan Holme football pitches; or the more recent days of mid-January in 2008 when the *Lancashire Evening Post* headline read 'Flooded Out' after a day when a fortnight's rain fell, causing chaos and misery for commuters by road and rail. In Preston, during the 2008 flood, the River Ribble burst its banks for the first time in thirteen years and riverside fields flooded – the waters of the Ribble lapped the doors of the Tickled Trout at Samlesbury and at the Yew Tree public house in Walton-le-Dale. According to the UCLAN staff at the Moor Park Observatory the rainfall had been over 1.75 inches in less than twenty-four hours.

In mid-June 2014 Preston faced another mopping-up operation after a week's rain fell in just fifteen minutes. On that Tuesday, the summertime flash flooding saw monsoon conditions in Preston. For twenty-four hours Preston was the wettest place in England.

It would therefore seem sound advice to carry your umbrella if the storm clouds start gathering and maybe a pair of wellington boots too, but be wary of holding an umbrella if the lightning strikes. As for the Goodwin Brothers' umbrella shop, it closed its doors for the last time in March 1997 after ninety-four years of trading. A lengthy drought had seen trade fall and cheap imports had flooded the umbrella market.

Floods on Broadgate were commonplace before the wall was built.

A rainy day at Preston Guild, 2012.

V

Vacations – Victorian Value from Frames

Vacations are something Preston folk look forward to and as far back as the late nineteenth century one Preston entrepreneur was busy arranging them. John Frame was a man set to pioneer travel for all classes to destinations they had not previously heard of.

In the year 1848 a tailor named John Frame celebrated the birth of one of his seven children at his Lanarkshire home. That child, on whom he bestowed his own name, was in later years to develop a travel business that was to cause a revolution in the holiday trade. With a background in the tailoring business, John Frame the Younger moved to Preston from Scotland and set

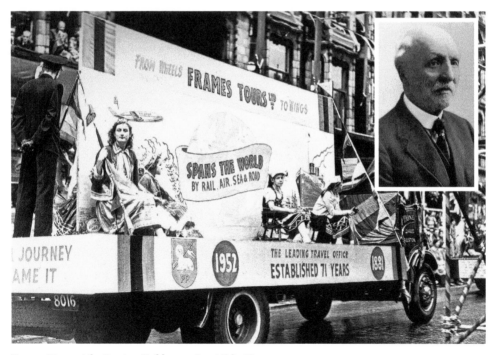

Frames Tours at the Preston Guild, 1952. *Inset*: John Frame.

himself up in a small shop in Cannon Street. A staunch Methodist and keenly involved with the local temperance movement, he moved into the tourism business almost by accident.

In the year 1881 a large body of temperance workers in Preston were invited to join the great choir of 5,000 voices at the Temperance Festival at the Crystal Palace. Having attended a previous gathering of this kind, John Frame was asked if he would arrange the trip. That historic trip, which took advantage of Preston's good railway communications, was arranged at a cost of only 5s per person for two days in the capital. So pleased were the trippers that it became an annual outing, with John Frame in the role of organiser.

His abilities as an organiser began to attract considerable attention and soon other bodies, including the Conservative Working Men's Club, were calling on his services to arrange excursions and soon he realised the potential for conducted tours. To this end he set up a travel agency that he eventually called 'Frames Tours', which quickly developed as he conducted a trip one week to London and a tour of Scotland the next. He also devoted a good deal of attention to daily excursions, including trips to football matches as Preston North End began to emerge as the 'Invincibles'. Even the travel arrangements for the football team were entrusted to his care and he arranged special railway trains to run to such places as Liverpool, Manchester, Sunderland, Newcastle and London.

The impact that Frames Tours made on the local scene can be judged by an account of the Preston holiday week in August 1906. The annual Wakes Week was not blessed with the best of weather as a considerable amount of rain fell. However, Messrs Frames showed characteristic enterprise and they organised conducted tours to London, Paris, Ireland, Scotland and Wales. Many daily outings were also booked through the local travel agent with the Isle of Man, Windermere and the seaside resorts of Fleetwood, Blackpool, Lytham and Southport all proving popular destinations.

As the years progressed, John Frame began to leave the more energetic side of the tourism organisation to his two sons, John and William. The business was booming: there were chartered steam cruises to Norway from Scotland, and tours of the Western Front battlefields from the First World War to allow bereaved families to visit war graves. Branches of the company were eventually opened in Paris, New York and London, from where John Frame guided affairs. Ever true to his Methodist principals, he had opened a number of temperance hotels in London and delighted in their success. Nevertheless, Preston remained at the centre of the business, with the company's Fishergate shop (which opened in 1912) often the first port of call for local holiday seekers. Soon postcards to the folks back home were landing on the doormat of many a Preston home.

In his later years he wrote a book entitled *My Life of Globe Trotting* (published in 1927), and in it he recalled those pioneering days that had built a travel business empire. He died in London in 1934 at the age of eighty-six. Control of the business was taken over by his sons, and then by his grandson. Frames Travel continued to progress over the next forty years and, in fact, by the time of Preston Guild in 1972, the company were proud to have over seventy offices throughout the country, being the official agents for numerous air lines, steamship companies, tour operators and railway companies. With local offices in Fishergate, Friargate, Church Street and on Fylde Road the business was prospering.

Eventually the company was targeted by Thomas Cook – the giants of the holiday business – who purchased the UK retail outlets in July 1985 for an undisclosed sum, just over a century after John Frame had arranged that first trip to the Crystal Palace. Perhaps John Frame would have been pleased because Thomas Cook, a Baptist preacher, had started his travel business back in 1841 by arranging a day's outing for the temperance workers of Leicester.

Two years later, Thomas Cook closed the Fishergate store and announced that in future the travel centre in St George's Shopping Centre would trade under the Thomas Cook banner, along with the other Lancashire branches in Leyland, Lancaster and Chorley.

These days, with the clamour for foreign holidays increasing, there are among our city traders a number of travel agents who are part of the modern-day scene, with Thomas Cook having also returned to a prominent Fishergate location not far from where John Frame traded in times gone by. Let's hope you have as much fun on your trips as John Frame gave to many Preston folk – sunshine, sea air and sand, all was grand.

A day at the seaside, as Furnival saw it.

Wholesale – Creating a Co-operative

Wholesale Co-operative enterprises were a Victorian initiative embraced by the people of Lancashire in particular. In 2013 the Co-operative Group celebrated their 150th anniversary after its beginnings in a small warehouse in Manchester in 1863 as the Co-operative Wholesale Society. The CWS was formed to meet the needs of numerous worker Co-operative societies that had sprung up in Lancashire, notably the one formed by those Rochdale pioneers. It was a way for the working classes, who existed on a meagre diet, to collectively purchase food and goods at a price that undercut the shopkeepers who exploited them. The pioneering schemes soon attracted the workers of Preston, many of whom lived on the breadline, despite their long days of toil in weaving sheds and factories.

As early as December 1860, the Preston Industrial Co-operative Society were holding a meeting in the Temperance Hotel in Lune Street, with some seventy shareholders attending. Having occupied a shop in Lancaster Road, they wanted to purchase that and the adjoining premises. Unfortunately, despite their best efforts, the timing of that particular enterprise was not good: the Cotton Famine was about to strike and thousands of mill workers were left idle.

Nonetheless, it was still an ambition of Preston folk to set up a Co-operative. In October 1869 the New Hall Lane Industrial Co-operative was opened with a shop at the corner of Geoffrey Street and Carey Street, partly thanks to the encouragement of neighbourhood mill owner Mr H. C. Outram. Sixteen working men had raised a share capital of £20 through weekly subscriptions and on the opening night the shop stocked 3 dozen candles, 1/2 lb of tobacco, 9 lbs of currants, forty onions and forty apples, a tray of buns and teacakes, twenty loaves, a sack of potatoes, 6 lbs of sausages and 6 lbs of black puddings, a slab of butter and one sheep. All the ingredients for a candlelight feast, no doubt.

A slow beginning, with takings of £20 a week, did not deter them. By 1873 they felt sufficiently established to open a second store in Adelphi Street, and in April of that year the collective became the Preston Industrial Co-operative Society Ltd. Shortly afterwards a shop in North Road was obtained and the rooms above were used as offices. By the end of 1874 other stores had been opened in Ashton Street, Walton le Dale and in New Hall Lane. In the decades ahead further stores followed in Brackenbury Road, Fletcher Road, Gerard Street, Marsh Lane, Bray Street, St George's Road, Wellington Road and London Road, indicating marked progress.

Preston's progress as a Co-operative was shown in 1907 when the 39th Annual Co-operative Congress was held in the town. They had plenty to be proud of, including their flagship store on Ormskirk Road, which was opened in 1892 by Alderman Edelston. It had cost £6,000 to build and provided tailoring, millinery, drapery and furniture departments. Membership was over 7,000 with a share capital of £63,682. With new stores having opened in East Street, Acregate Lane, Holmrook Road and Broadgate before the turn of the century, there was a feel-good factor. The introduction of a monthly *Preston Co-operative News* helped to bring the community together with excursions to seaside and country, concerts, field days and sports events.

The Co-op community thrived despite the trauma of two world wars and the days of food rationing. It became the Co-op familiar to later generations, with slabs of butter and lard straight from a barrel, cheese cut with a wire, and bacon and ham strung from the ceiling and sliced from the roll with a revolving blade. Biscuits were stored in glass-topped boxes while potatoes, onions and carrots were collected loose from sacks and weighed accordingly. Perhaps most important of all, you got some more dividend stamps to put in your book – savings for a rainy day.

The Preston Trade Directory of 1960 showed that besides the Ormskirk Road store there was a warehouse and bakery in Moor Lane, a coal depot in Carroll Street and some fifty

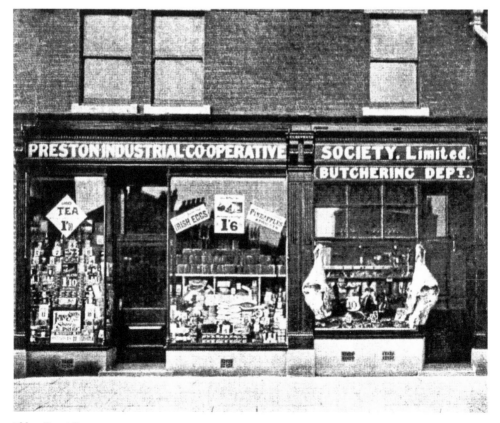

Eldon Street Co-op, *c.* 1907.

branches within the Preston area. Like many businesses, the Preston Industrial Co-operative was the subject of takeovers and mergers, and by the 1970s was part of the Greater Lancastria Co-operative Society. In mid-1975 they opened a new food store on Friargate Walk in St George's Shopping Centre, transferring their food trade from Ormskirk Road. A year later they were announcing the opening of their multimillion-pound superstore in Starchhouse Square, known as Lowthian House. With their Lancaster Road store having been upgrading in 1972, things seemed to be looking good for the Co-op in Preston.

Eventually another merger followed, with the old Preston society becoming part of the United Co-op group and the Lancaster Road store being closed down in 1988 – a fate that had already befallen a number of the local branches and with more to follow by the dawn of the 1990s as the supermarket giants began to dominate.

Despite all that followed, the Co-operative Group of today still plays a significant part in Preston. The move to late closing helped to increase their popularity locally and you can still shop at the Co-op on Plungington Road, on Norbreck Drive in Ashton, on Granton Walk in Ingol, on Pope Lane in Penwortham and within the UCLAN on Fylde Road.

Many of the old Co-op branches were very similar in design and their unique architecture can be seen dotted all over our city. Some of the buildings have been put to good use, while others have been left to decay, but all are part of our history and sure to stir a memory or two. Those pioneering wholesale Preston grocers of 1869 could never have imagined the impact their enterprise would have on Preston.

A modern Co-op store in Granton Walk, Ingol.

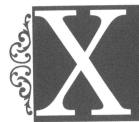

X-Rated – Censorship from the Watch Committee

X-rated censorship is something we are well aware of and it was certainly at the forefront of the Preston Corporation, with a body known as the Watch Committee in place to ensure that moral corruption was prevented.

Back in late August 1915, Chief Constable J. P. Ker Watson went to the Kings Palace Theatre in Tithebarn Street (which opened in 1913) to view the matinee screening of a film called *Five Nights* – which was based on a book by Victoria Cross. After watching the screening, along with an audience of hundreds, he immediately wrote a letter to the proprietor of the cinema. The letter was delivered before the scheduled evening performance; it stated that the police believed it to be an objectionable and offensive film and contrary to the terms and conditions of the cinema's regulations. Consequently, if shown again, it would lead to local authority action in accordance with the Kinema Act.

The film was duly withdrawn and it led to the appearance of the chief constable at Manchester Assizes in February 1916 before Mr Justice Shearman. An action had been brought against him by the National Film Agency for damages for alleged improper interference with the plaintiffs' right to publicly exhibit the cinematograph film and for alleged libel. The fact that the chief constable had spoken to the press giving his views as to the unsuitability of the film, had prompted other Lancashire cinemas to withdraw screenings, adding to the agency's anger.

It was stated that the film had been approved by a board of film censors and the agency claimed they had spent £5,000 in securing the rights and advertising it, and they regarded Mr Ker Watson's actions as malicious and unjust. The silent film, directed by Bert Haldene, was billed as a romance and starred New Zealand-born actress Eva Balfour and Thomas MacDonald.

One of the witnesses called was Walter Leslie Knight, the manager of the Theatre Royal. He stated that the picture was offered to him before release, but he had heard rumours it was unsuitable and declined it. When quizzed by the prosecution, it was suggested that Preston was very sensitive on these matters, with notoriously Puritanical views. He responded by saying that was not the case and that he would refuse a picture of this kind at any time.

In summing up, His Lordship said that, by law, any member of the public had a right to communicate his opinion to another on any matter of public interest. Having seen the film,

in which there was a fair amount of hugging and cuddling, the jury had to decide if it was indecent. His Lordship also asked the jury to consider if the chief constable had a grudge or grievance against the plaintiffs and whether his actions were justified. It was after 6 p.m. when the jury retired; they returned an hour later with a verdict for the defendant.

Probably due to its notoriety, the film drew the crowds in many cinemas across the country and Eva Balfour went on to appear in popular silent movies for the next five years. Victoria Cross was a prolific author who came to prominence in the late Victorian period and whose novels, it was said, should be read behind closed doors with love, lust and passion in abundance within their pages.

In September 1933, the Preston Watch Committee, who had banned the film *Frankenstein* a few months earlier, attended a private screening of the gangster film *Scarface* at the Theatre Royal. Said to be a story of gunmen, murder and lust, the verdict released by Mayor T. C. Rainford was that it was unsuitable for showing in Preston. A couple of years later, in October 1935, attempts were made to screen *The Bride of Frankenstein*. Once again, a ban was issued, with one committee member declaring that the film was unpleasant, gruesome and shocking. Another attempt to show the horrors of *Frankenstein* was made in March 1939, but yet again the Preston Watch Committee, who had a private viewing at the New Victoria of the film *Son of Frankenstein*, chose to ban it.

Preston had certainly gained a reputation for the censorship of films in the 1930s, but there was surprise in mid-September 1956 when the town banned the showing of *Rock Around the Clock*; however, this time it was not to protect the morals of the townsfolk, but because screenings in other towns had been accompanied by disorderly behaviour. The youth of Preston were duly denied this opportunity to see Bill Haley and His Comets on screen for fear of hooliganism.

Generally the censorship of films was becoming more relaxed by 1954, with the Lido cinema on Marsh Lane becoming the Continental Cinema, where X-rated films were the order of the day. The bold new venture failed to attract large enough adult audiences and closed in 1959. The screenings of the adult films were moved to the Queens cinema on Tunbridge Street, with the audience strictly over eighteens only. The Continental Cinema had found a good location and soon had an audience of regular patrons who enjoyed such films as *Paris Vice Patrol*, *Love Is My Profession* and *Dens Of Evil*. A bonus for courting couples were the double seats. These nights would continue into the 1960s, although by early 1964 the cinema had become yet another bingo hall.

Scarface was banned in Preston in 1933.

It all seems a far cry from the present day and the films on offer to local audiences at the multiscreen Odeon cinema on Riversway and the Vue cinema at the Capitol Centre. The Watch Committee would probably not approve and maybe even choke on their popcorn!

Above: The Continental Cinema on Tunbridge Street.

Left: Brigitte Bardot was an attraction at the Continental Cinema.

Y

Young Ahearn – Preston's Great White Hope

Young Ahern, a local boxer, was exciting the sporting folk of Preston a century ago. Born in Preston in December 1892 as Jacob K. Woodward, he had begun his professional boxing career in November 1913 in Paris. He lost to Albert Badoud by a knockout in the eighteenth round, but within three weeks he was back in a Paris boxing ring to knock Henri Piet out in the seventh round. Fighting next in Liverpool, he lasted fifteen rounds against Johnny Basham only to lose on points. Shrugging off this further setback, Ahearn, who had trained in America, then embarked on an impressive run of victories: three triumphs in Paris and a couple in Preston, including a points victory over Gunner Budgen at the Adelphi AC.

Ahearn then headed to London, where he had a bruising encounter – over twenty rounds – against Eddie Elton, which ended with a points victory in March 1914. Two months later Ahearn appeared at the National Sporting Club, Covent Garden, London, against the undefeated Private Pete Braddock, whom he outclassed and defeated in the ninth round. He was described as a cleanly built, upstanding fellow and more like a light heavyweight who could punch with both hands. A homecoming bout at a packed Prince's Theatre in Preston followed at the end of May against the formidable Harry Duncan. Once more, Ahearn stuck to the task and after fifteen rounds his arm was raised in victory.

The next fight for Ahearn took place in London at the Premierland arena in Whitechapel against Sid Burns, an experienced fighter with fifty victories in his locker. Halfway through the second round, Burns was floored with a heavy right to the jaw that left him unconscious for a couple of minutes. The victory had the boxing scribes describing Ahearn as a future champion and earning him the title the 'Dancing Master' for his ring movement.

Of course, the days of the bare-knuckle fights had long gone, and back in 1892 James J. Corbett became the first boxing heavyweight champion wearing gloves to become champion while embracing the Marquess of Queensberry's rules. The world heavyweight title was the one most coveted by boxers and gave them the chance of great wealth.

In those late Victorian days, there was often racial tension between champions. In fact, black heavyweights felt they were being shunned by the boxing fraternity and so set up their own unofficial boxing title bouts. Jack Johnson was one of the black heavyweight boxing champions. In December 1908 he became the first African-American world heavyweight champion after defeating Canadian

Tommy Burns. He was a controversial champion and defeated a string of boxers, dubbed as the 'great white hopes', while refusing to fight a black opponent during the first five years of his reign.

After the legendary former undefeated heavyweight champion James J. Jeffries came out of retirement and failed to dethrone the champion, the search was on for a 'great white hope'

YOUNG AHEARN v. SID BURNS.

One of the greatest middle-weight battles of the season takes place at Premierland on Monday, when Young Ahearn meets Sid Burns in a twenty rounds contest. Both men have trained assiduously for the match—Burns at Whet-

SID BURNS. **YOUNG AHEARN.**

stone and Ahearn in Paris—and with both sides confident of success it should indeed be a fine contest.

Above: Young Ahearn at the top of the bill.

Left: Preston's Young Ahearn, the 'Dancing Master'.

and a controversial unofficial World White Heavyweight Championship began in the hope of eventually finding someone able to defeat Jack Johnson.

On New Year's Day 1913, Arthur Palzer met Luther McCarty in California to determine the 'White Heavyweight Championship' of the world. McCarty won the title by way of a TKO in the eighteenth round. It would be a title he would hold for the rest of his life, which would only be a short five months. In May 1913 Canadian Arthur Pelkey fought McCarty for the title in Calgary and delivered a knockout blow in the first round. Sadly, McCarty was pronounced dead within a few minutes, a coroner's inquest ruling that he had died from a cerebral haemorrhage caused by a previous injury.

Pelkey was distraught after the death of McCarty and was never the same fighter. He lost the white heavyweight title to Gunboat Edward Smith early in 1914 – beaten on a TKO in fifteen rounds. It was then announced that Smith would defend his title against the European Heavyweight Champion Georges Carpentier in mid-July 1914. All eyes were now on Preston's own white hope Young Ahearn, and it was announced in the boxing press that he was a serious contender for the controversial title. The title contest between Smith and Carpentier was held at the fashionable Olympia in London. The audience, mainly in evening dress, witnessed a fascinating contest, with Smith cautioned twice for striking low blows. Then, in the sixth round, as Carpentier overbalanced, Smith struck him a vicious blow to the head; it was declared a foul punch and enough to have him disqualified.

The next day it was announced that the new champion would meet Young Ahearn, the fight attracting a purse of £10,000 and to be held over twenty three-minute rounds. Ahearn was full of confidence about his ability to tackle Carpentier. In preparation for the bout, Ahearn went into training at Brighton, accompanied by his trainer Billy Cram. A couple of weeks later, with the First World War looming, it was announced that Carpentier had returned to his French homeland to prepare for military service and the match with Ahearn was cancelled. At this point Gunboat Smith – still licking his wounds – agreed to step into the breach and fight Ahearn. The scheduled venue was Shepherd's Bush in London and Ahearn gave the watching press an impressive exhibition of his talent with three sparring partners at his Brighton training camp.

Unfortunately, as the mid-August clash approached, Ahearn went down with a chill and had to request a week-long postponement. The delay did not suit Smith, who told the sporting press that he wasn't prepared to hang around indefinitely and had packed his bags to return to the United States. Smith had been offered £1,750 for the bout with Ahearn and after pocketing £100 for the delay, he took flight. His boxing career in America lasted until 1921, although he never reached the heights his early promise suggested. As for Georges Carpentier, he would gain the highest French military honours as an aviator during the First World War and returned to the boxing ring afterwards to continue a highly successful career. In April 1915 when Jess Willard beat Jack Johnson for the world heavyweight title, the world White Heavyweight crown became defunct.

For Prestonian Ahearn, his future was in the United States, where he resumed his career in late October 1914 after victory in New York against Freddie Hicks. He eventually settled into the middleweight category and met a couple of title contenders during an unbeaten twelve months as the United States warmed to the 'Brooklyn Dancing Master' and his winning style. In all, his boxing career would continue until 1924, by which time he had fought over 130 bouts and won over eighty of them, including fifteen by a knockout. He died in 1979 aged eighty-six.

Zebra Crossings

Zebra crossings are an important tool of road safety. Indeed, even in these days of the more technologically advanced pelican and puffin crossings and traffic-monitored safe-crossing systems, there is still faith in the traditional way of crossing the road.

In 1948, as death tolls mounted due to an increase in road traffic, work was underway to produce a safe way of crossing the road. Initially, over 1,000 zebra crossings were introduced nationwide with alternative lines of blue and yellow marking the way. The success of these first crossings led to their widespread introduction in 1951, with a change to alternative black-and white-strips leading to improved visibility.

It's true to say the introduction of zebra crossings was not without teething troubles in Preston, with a number of motorists being fined and censored. In June 1952 a lady was struck by a van on the London Road crossing, earning the motorist a £5 fine. Tragically, a couple of weeks later, a seven-year-old school girl was knocked down and killed on a zebra crossing on Garstang Road. The driver of a cattle truck had his view of the crossing obscured by a bus that had stopped at the nearby bus stop. A misadventure verdict was recorded at the inquest, with the jury recommending that the bus stop be moved at least 30 yards away.

In the UK a school crossing supervisor (or school crossing patrol officer) is commonly known as a lollipop man or lollipop lady, because of the circular stop sign he or she carries that resembles a large lollipop. The phrase was coined in the 1960s when road safety awareness programs were rolled out in schools throughout the UK, and the crossing patrols were introduced by the Road Traffic Act of 1967.

In 1971, after twenty years of usage, zebra crossings became an integral part of the road safety campaign known as the Green Cross Code, which replaced the previous 'kerb drill' used to safely cross the road. The contrast of thick white stripes against the black tarmac – sometimes black paint too, when necessary – make zebra crossings one of the most easily recognisable and visible road markings. They often have Belisha beacons – the amber-coloured light orbs – either end of the crossing to add further visibility at night-time or in adverse weather conditions.

The traffic-choked artery of New Hall Lane was in the news in 1972 after seven deaths and numerous injuries over an eighteen-month period. Pedestrians were being urged to cross this road cautiously and use the zebra crossings – even if they were further away than their intended destination. The zebra crossing at the corner of Skeffington Road was a particularly busy one.